W9-BIN-596

CAPTURE
THE BEAUTY
IN NATURE

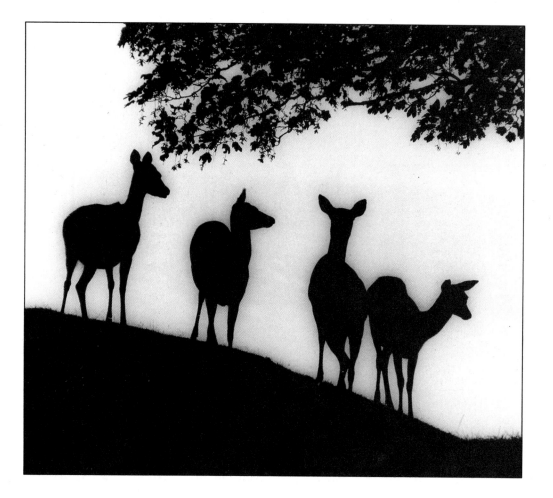

CAPTURE
THE BEAUTY
IN NATURE

Published by Time-Life Books in association with Kodak

CAPTURE THE BEAUTY IN NATURE

Created and designed by Mitchell Beazley International
in association with Kodak and TIME-LIFE BOOKS

Editor-in-Chief
Jack Tresidder

Series Editor
John Roberts

Art Editor
Mel Petersen

Editors
Louise Earwaker
Richard Platt
Carolyn Ryden

Designers
Marnie Searchwell
Lisa Tai

Assistant Designer
Stewart Moore

Picture Researchers
Brigitte Arora
Nicky Hughes
Beverly Tunbridge

Editorial Assistant
Margaret Little

Production
Peter Phillips
Jean Rigby

Consultant Photographer
Michael Freeman

Coordinating Editors for Kodak
John Fish
Kenneth Oberg
Jacalyn Salitan

Consulting Editor for Time-Life Books
Thomas Dickey

Published in the United States
and Canada by TIME-LIFE BOOKS

President
Reginald K. Brack Jr.

Editor
George Constable

The KODAK Library of Creative Photography
© Kodak Limited. All rights reserved

Capture the Beauty in Nature
© Kodak Limited, Mitchell Beazley Publishers,
Salvat Editores, S.A., 1983

No part of this work may be reproduced or utilized in
any form or by any means, electronic or mechanical
including photocopying, recording or by any information
storage and retrieval system, without the prior
permission of the original copyright owners.

Library of Congress catalog card number 82-629-80
ISBN 0-86706-221-5
LSB 73 20L 08
ISBN 0-86706-223-1 (retail)

Contents

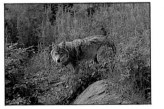

THE WONDERS OF NATURE

The natural world strikes a chord in all of us. To look down from a mountain peak or out across a vast sea, to stroll through the scented stillness of a pine forest, to watch a bird gathering nesting materials – these are experiences that can put us in touch with our own natures. And for photographers, the sheer range of subject matter offers unique opportunities to go exploring with a camera.

The pictures on the following nine pages show how richly varied nature photography can be, often with the most basic equipment. Nature is full of marvels and surprises. They may be on the awesome scale of the electrical storm that has transformed a familiar landscape in the picture opposite. Or they may reveal themselves only to the patient observer who can note an insect's perfect resemblance to a leaf. This book looks at both the landscape and the creatures that inhabit it, showing how to find rewarding subjects and compose pictures that capture the beauty, strangeness or grandeur of the natural world in all its forms.

Forked lightning fragments the livid night sky above Tucson, Arizona. To achieve the full spectacular effect, the photographer left the shutter open for several seconds to record a number of consecutive flashes on one image.

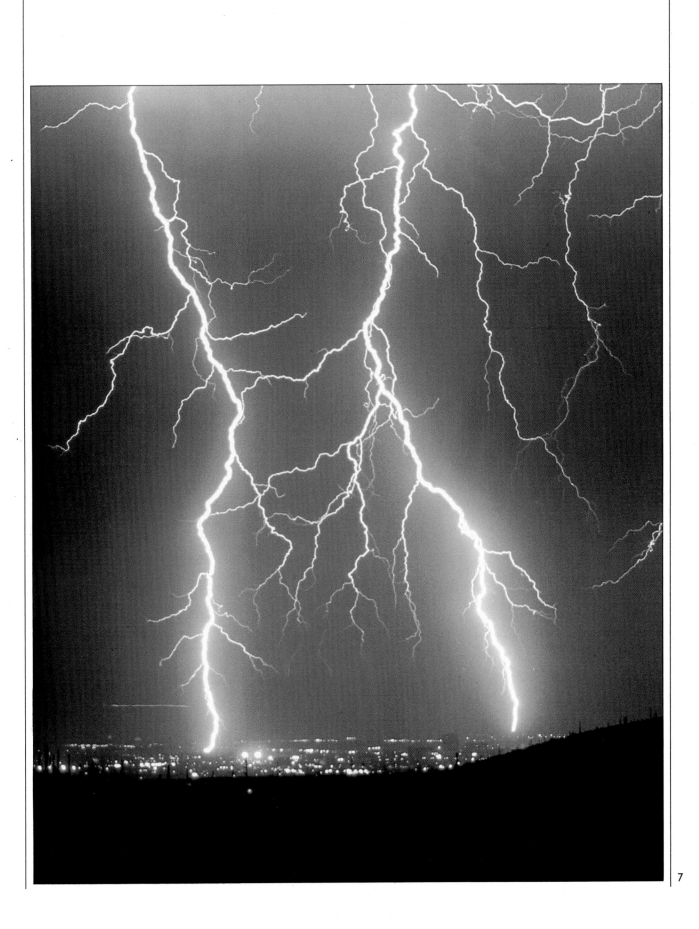

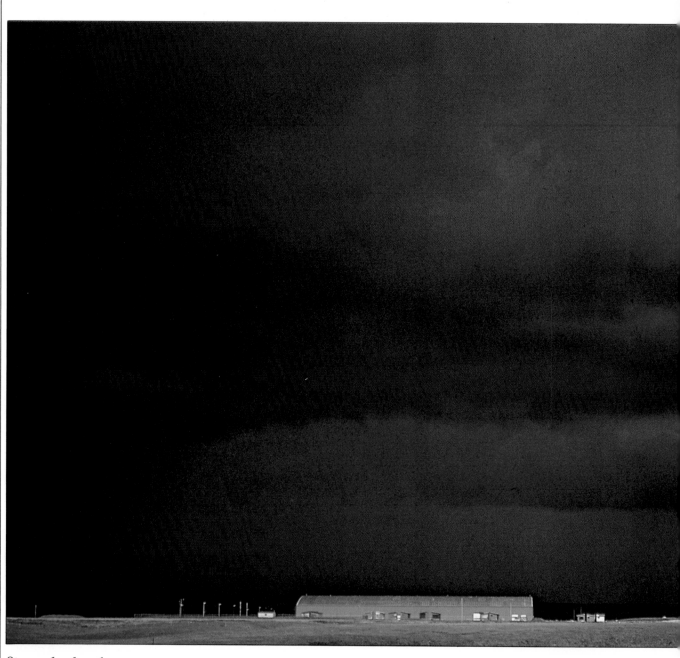

Storm clouds *gather over a remote*
Canadian farmstead. The bold approach to
composition, with the leaden sky taking
up almost the entire frame, makes the
most of the strange lighting effect. The
long red barn, centered in the frame, is
a strong visual element that helps to
break up the straight line of the horizon.

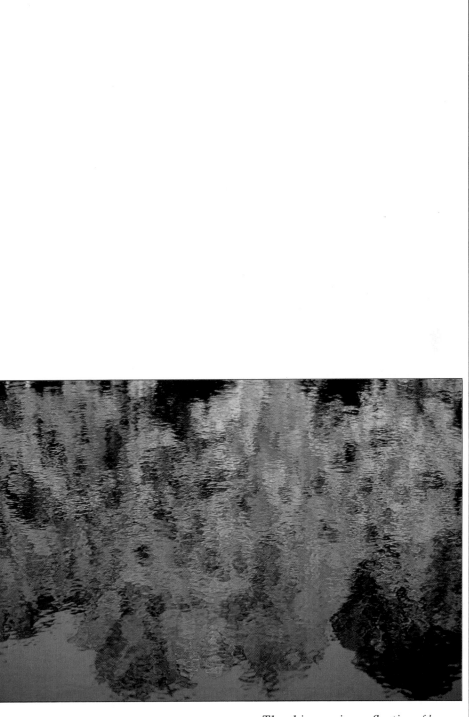

The shimmering reflection of leaves changing color in the fall gives this image the quality of an Impressionist painting. The movement of the sunlit water conveys the rich, glowing colors more effectively than would a more conventional view of the landscape.

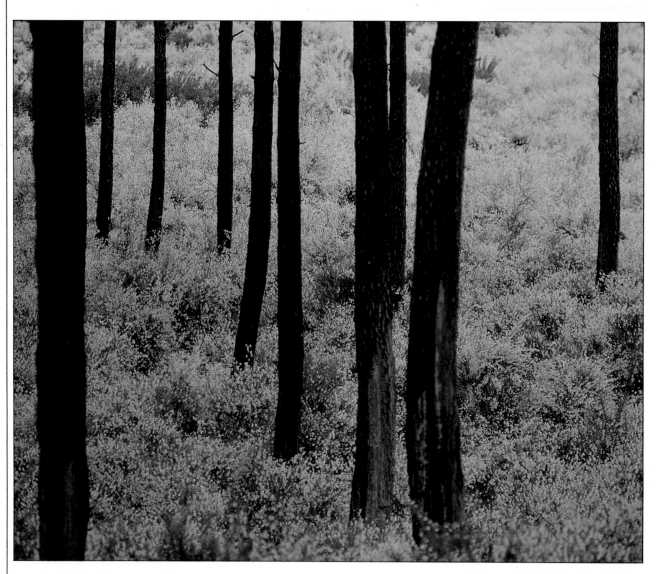

The slender trunks of pine trees
add graphic interest to a uniform area
of shrubs in bloom. Skillful framing has
brought out abstract qualities of line
and color that a wider view would lack.

A woodland stream (right) cascades
over moss-covered rocks. The photographer
set a very slow shutter speed of 1/4 to
accentuate the rushing movement of the
water around the rock in the foreground.

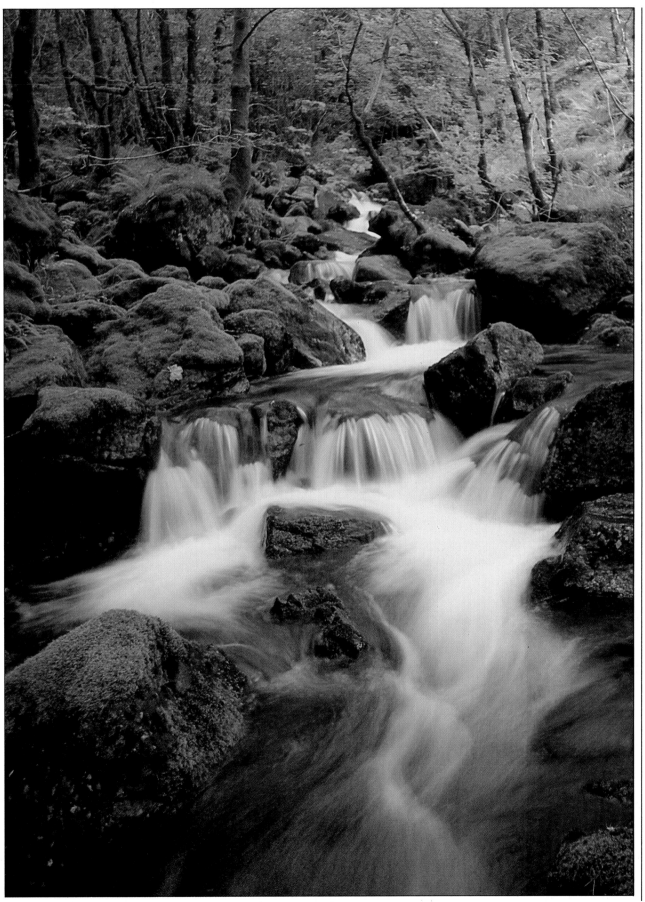

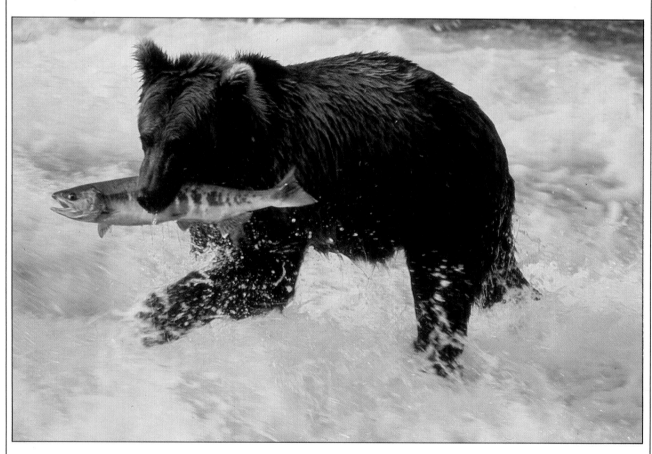

An Alaskan brown bear scoops up a fine fish in icy waters. Preoccupied with finding a meal, the animal was not aware of the well-hidden camera. The photographer had waited with a 200mm lens and set a shutter speed of 1/250 to record the peak moment of the catch.

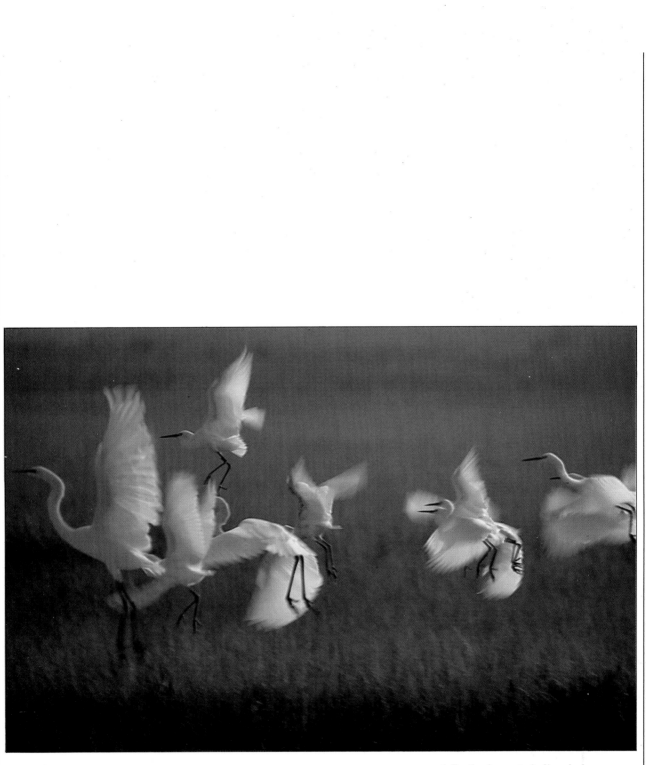

A flock of egrets *is disturbed into sudden flight. The photographer used a 300mm lens to obtain good detail of the subjects against an unfocused background. A shutter speed of 1/125 has frozen some movement but blurred the rapidly beating wings to suggest the graceful rhythm of the birds in flight.*

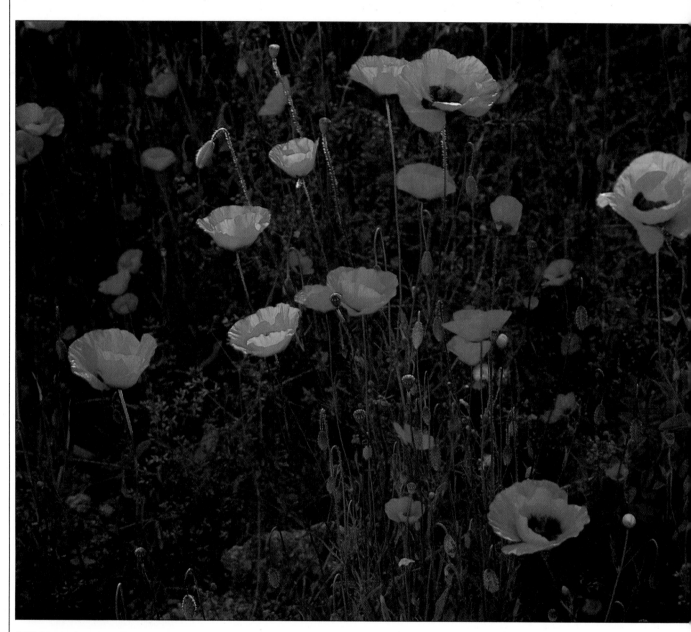

Wild poppies *flourish on a patch
of rough ground. The photographer moved
in close with an 80mm lens to fill the
frame with the small subjects and used
backlighting to intensify the brilliant,
clear colors of the flowers.*

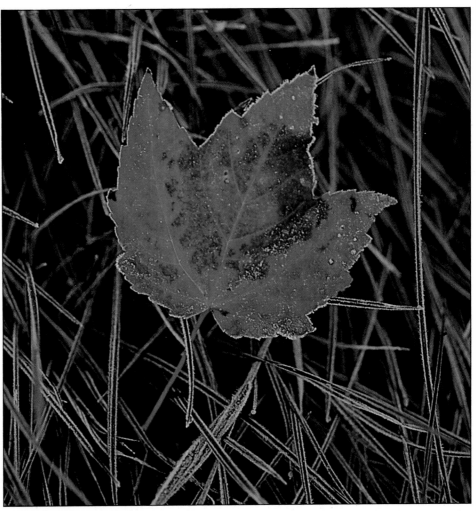

A fallen leaf, coated with frost, lies caught in a mesh of stiff grass. The photographer carefully composed the picture to reveal the intricate patterns of the tangled grass and the leaf's structure, traced with silver. He used a normal lens at its closest focus – 1½ feet.

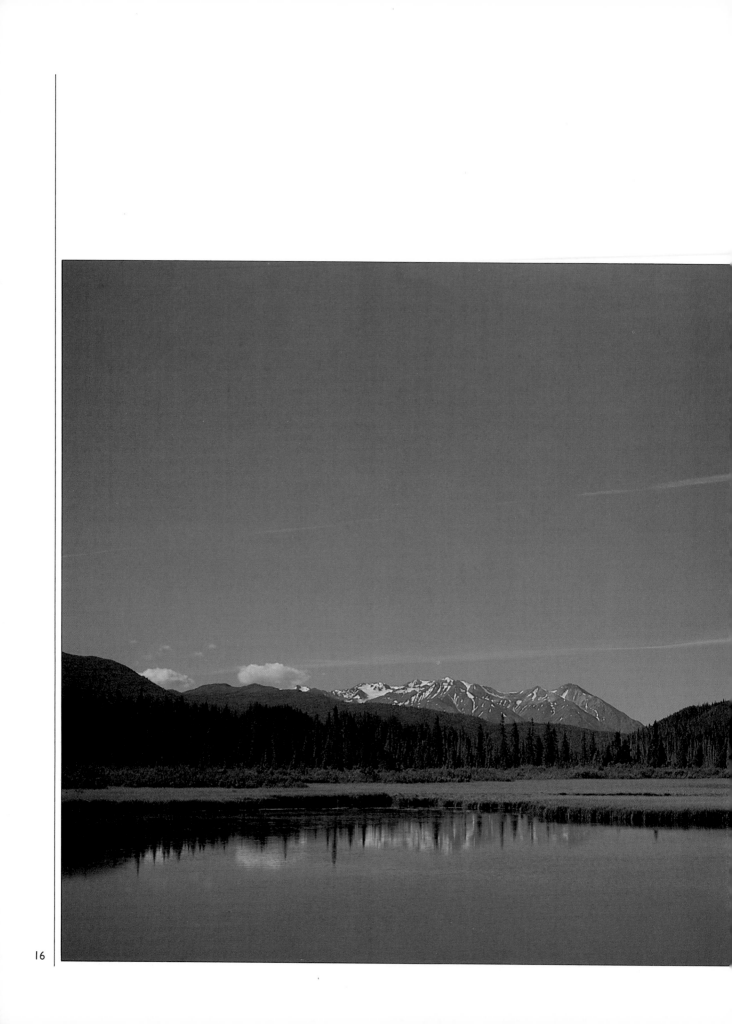

THE NATURAL LANDSCAPE

For photographers, as for painters, landscape holds a lasting appeal. No other subject is so accessible; what we see can be photographed today or tomorrow, in natural light and usually without special equipment. Moreover, the subject seems almost inexhaustible, ranging from the tranquil beauty of fertile woodlands to the stark grandeur of open mountains and deserts.

Yet good landscape photographs are rare. Partly because there are no obvious technical problems, the tendency is to assume that our strong impressions of the scenery will translate themselves onto film effortlessly. The skill of taking landscape pictures lies in understanding how a scene will work photographically instead of just being overwhelmed by the beauty of it all. To compress the sheer scope of a landscape into one image, you need to isolate the visual qualities that will re-create the panoramic view you see or suggest its depth and distance. This section explains some simple techniques that can help you to convey scope, capture natural drama and reveal patterns and textures in ways that will give fresh, original expression to the classic landscape themes.

A still lake mirrors a distant snow-capped peak in the Kluane Game Sanctuary, Yukon, Canada. Framing to show a broad expanse of sky and using a wide-angle lens emphasized a panoramic view.

The spirit of the place

The appeal of a particular place is evident when you are actually there, because you use all your senses to appreciate the surroundings. But this strong impression can be difficult to convey on film. The play of light, the feel of the wind and the sounds and smells of the sea or the countryside all contribute as much to your experience as the view itself.

To have any hope of conveying this overall impression in a photograph, you need to give time and thought to selecting an image. Try first to decide exactly why the scene attracted you photographically. Perhaps you were drawn to permanent features – the shape of a mountain or the fault lines in a rock. Or perhaps the visual quality that attracted you is more transient – the patterns of shadows or the deep-red color of sandstone cliffs at sunset.

The feeling of a particular season, accentuated by lighting conditions, can play a powerful part in creating atmosphere. For example, in the picture below, a low sun emphasizes the cold crispness of a winter landscape. The photographer has distilled his own experience of the scene largely by the choice of his camera angle in relation to the light.

An even clearer example of how technique can serve a personal interpretation is the seascape opposite. The photographer has responded to the shapes of trees growing tenaciously on an islet and accentuated this by selecting an exposure that shows them in silhouette. And in the picture at the bottom of the same page, a choice of lens and a viewpoint that fills the frame with trees convey the lonely vastness of forested hills in fall.

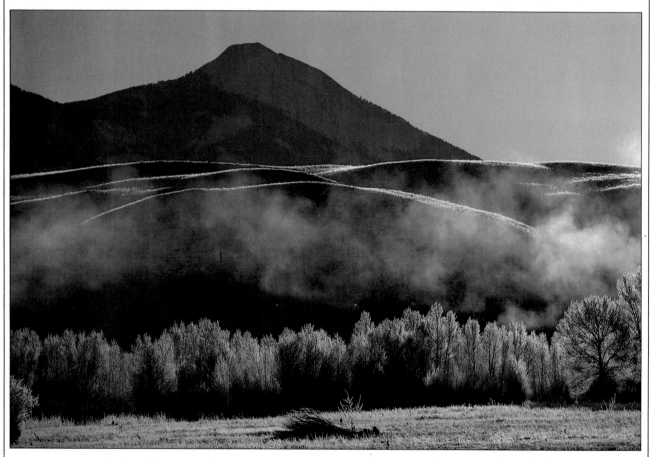

A low morning mist hangs over the frosted ground in Montana's Paradise Valley. The photographer made use of the backlighting from a low sun to highlight a furring of frost along the ridges and the lacy pattern of the rime-covered branches.

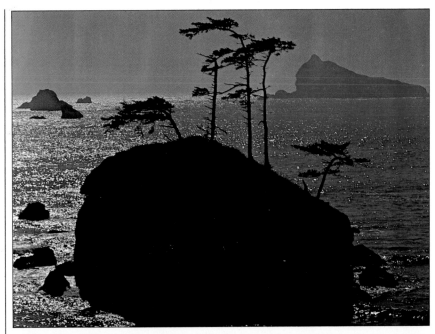

Wind-beaten trees cling to a tiny island. To obtain the silhouetted shapes of the stunted branches and the groups of rocks studding a glittering sea, the photographer deliberately underexposed by two stops, setting 1/250 at f/16.

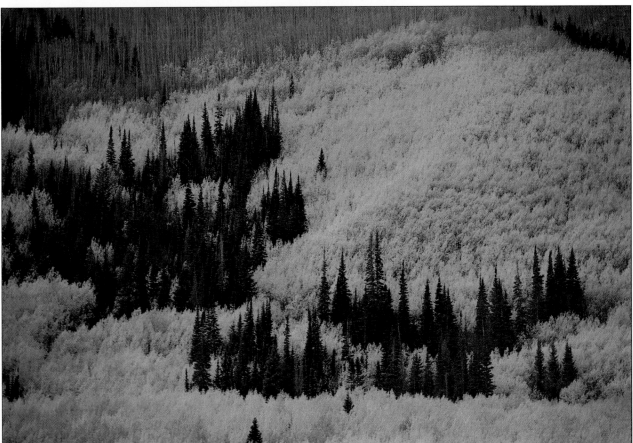

Tall evergreens rise above a yellow mass of woodland turning its leaves in fall. The photographer chose a high viewpoint on a ridge, used a 200mm lens and set a small aperture of f/16 to ensure maximum crispness.

Viewpoint and scope

Seen from an open viewpoint, the whole landscape appears to spread out in a sweeping panorama. A good photograph of such a scene can re-create for the viewer the same feelings of freedom and exhilaration that originally inspired the photographer.

To evoke these feelings, concentrate attention on the distant horizon and try to strike a harmonious equilibrium between land and sky. This is easiest if you use a wide-angle lens – which naturally takes in a broader view – and compose the image so as to eliminate the foreground, as in the picture at right.

A broken canopy of clouds can help to draw the eye forward across the landscape, as the picture below shows. Point the camera slightly upward so that the horizon does not divide the image into two exactly equal parts.

Even with a normal lens, you can often suggest the openness of landscape by ordering or making a big print and cropping the image at top and bottom, as shown at the bottom of these pages. The use of slow film will help make sure that the enlarged part of the picture does not look too grainy.

Fluffy clouds cast a pattern of shadows on a spread of green fields. A 28 mm lens slightly distorted the shape of the clouds, which appear to be moving rapidly toward the distant horizon.

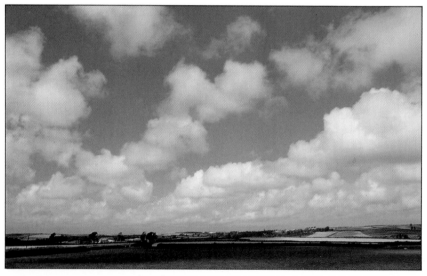

A thicket of silhouetted trees is an interesting composition as it appears in the original picture (above). But by cropping to a horizontal shape, the photographer further strengthened the image. The cropped version, with much of the foreground eliminated, allows the viewer to scan the horizon – as if standing right behind the camera on the side of the darkening hill.

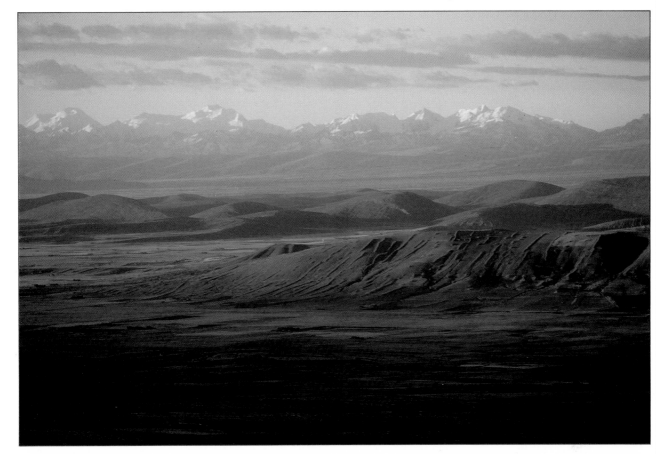

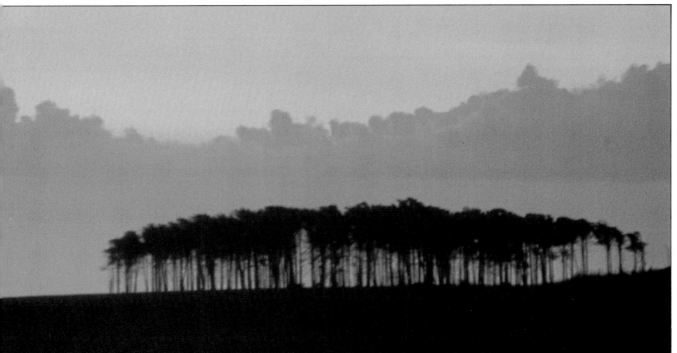

Viewpoint and depth

Depth and distance are important elements in most landscape pictures. One useful way to suggest depth is to use a wide-angle lens and choose a viewpoint close to the ground. This will create an image that emphasizes the expanse of land stretching away into the distance, as shown at the bottom of this page. Because such a photograph relies for its effect on sharply focused detail from the foreground through to the horizon, you should set the lens to a small aperture to maximize depth of field.

An alternative approach is to use atmospheric haze to give an impression of distance. To exagger-ate the effects of haze and mist, use a telephoto lens – which compresses distance – and compose the image to include both near and far features, as in the picture below.

Even on a clear day, careful composition can help to give a sensation of depth and scale. The picture on the opposite page illustrates how this can be done successfully. The photographer framed this scene so that a nearby, shadowed pillar of stone dominated the view. Without this point of interest in the foreground, the image would have looked more two-dimensional.

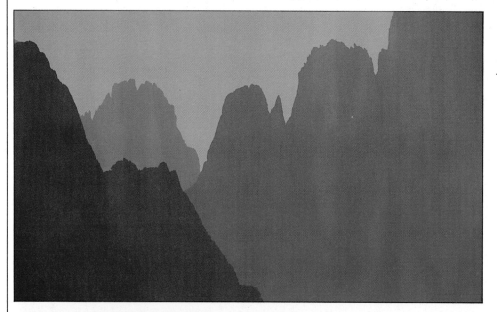

Mountain crags recede into a swirling mist in the Italian Dolomites. The photographer left his UV filter off the lens to make the mist seem thicker and thus increase the apparent distance between the peaks.

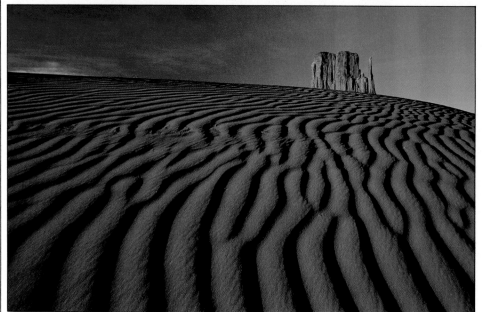

Windswept dunes lead the eye back to the horizon in Utah's stark Monument Valley. Using a 28 mm lens, the photographer crouched down on the ground so that the snaking lines in the sand dominate the image.

A natural pinnacle towers over the landscape. in Bryce Canyon, Utah. By taking the exposure meter reading from the far hills and sky, the photographer rendered the rock as a stark silhouette. This black shape in the foreground helps to create a sense of distance.

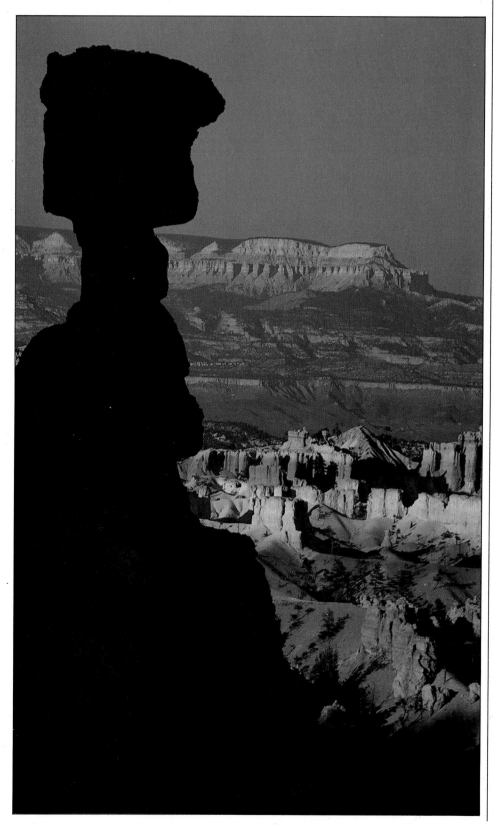

The selected view

Taking a panoramic view of a landscape is rather like painting a picture with a broad brush. The grandeur and atmosphere of the place come across strongly, but the picture often lacks selectivity of image – and misses fine details and definition.

Filling in these details demands a very different approach to photography, for the wide-angle lens that was so helpful in showing the all-encompassing view proves less useful for closing in on the specifics of the scene. Instead, the narrow angle of view and magnifying power of a telephoto lens provide the photographer with the facility to isolate selected areas of the scenery.

From a single viewpoint, a telephoto lens gives you a wide choice of pictures – each of which may be quite different. These selected angles need

searching out, as they are rarely obvious at first glance. The simplest way to find an effective image is to use the lens and camera as a flexible viewing aid. Swing the camera around to scan the scene, trying out as many compositions as possible before pressing the shutter release. You may be surprised at how the lens can suggest images that your eyes would never have seen otherwise.

Telephoto lenses are not quite as easy to use as normal or wide-angle lenses, and the longer the focal length the more care you must take. You will need a firm support to prevent camera shake; either use a tripod or rest the lens on a solid object. When taking pictures into the sun, even a lens hood may not provide enough protection against glare. As an extra precaution, shade the lens with your hand.

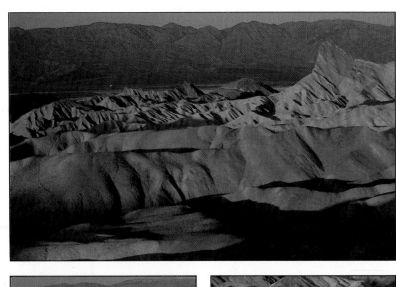

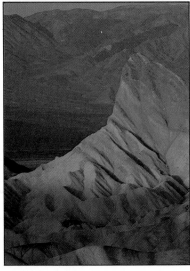

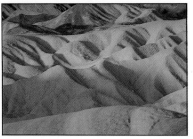

Tighter framing
The eroded landscape of Zabriskie Point, California (top), looked reasonably interesting through a 55mm lens. But by using 180mm and 400mm lenses (left and above), the photographer showed the shapes and shadows of the hills in stronger, more selective compositions.

A single tree trunk makes an elegant pattern when picked out by a 200mm lens. In a broader view, the curved branches would have looked far less striking.

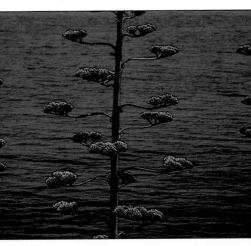

A palm-fringed beach is distilled into an image of simple beauty by a 300mm lens, used from across the bay so that sea, beach and hills form three clean bands.

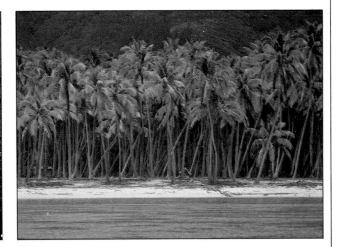

Grasses and poppies create a clamor of color, but from ground level, the scene was disappointing. By climbing a nearby hill and using a 200mm lens, the photographer eliminated the horizon and filled the frame with red and green.

25

The marks of man

Many landscape photographers attempt to exclude signs of human habitation or at least play them down. But the pictures here show a more positive response. In all three the landscape is largely natural, but some human element forms a key part of the image: a rough track cuts through an immense wilderness, stone walls thread a hillside with pattern, and a red and white deck chair adds a splash of color in a somber park. The photographers could all have changed viewpoints or lenses to minimize or exclude the human elements, but chose instead to make them cornerstones of the compositions.

Such signs of human activity need to be included with care. You can easily mar landscape pictures by allowing power lines, advertisements, parked cars, roads, or even people to clutter an otherwise unspoiled and natural scene. Keep these elements out of the frame unless you can see a way to use them effectively.

First, carefully study the scene to see if anything at all intrusive appears in the viewfinder. If you spot an unwanted detail, try adjusting the composition. For example, by using a wide-angle lens and moving a foot or two to one side, you may be able to hide the offending detail behind a rock, a tree or the crest of a slope. Narrowing the view with a lens of a longer focal length can also be useful. But if you really want to show untouched landscapes, the best tip is to take pictures early in the morning when there will be fewer cars or people.

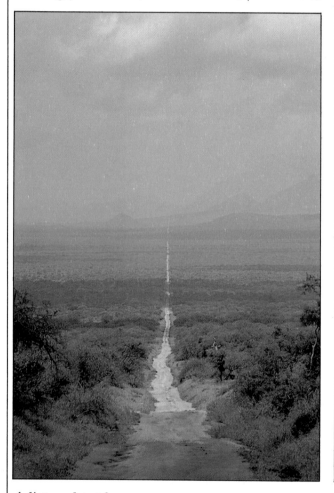

A dirt road stretches into the distance across an African plain. By centering on this ribbon of color, the photographer found a bold composition in an almost featureless landscape.

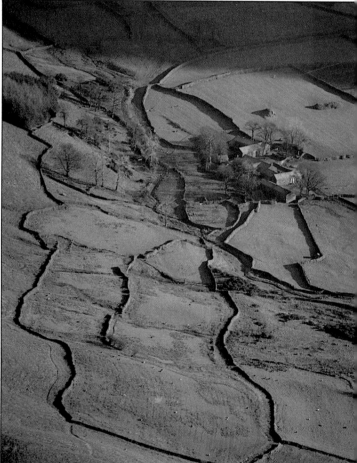

Walled fields surround a lonely English farm. These human creations, framed from a distant slope with a 200mm telephoto lens, made a more interesting picture than the barren hillsides higher up.

A backlit chair stands out brightly amid the dark trees of a city park in the evening. The photographer used a 105 mm lens for a selective view that included the chair as a focal point of the composition.

A sense of the past

Because their basic features are fixed, landscapes generally have a timeless quality. Sometimes this can make photographs seem bland and static – but not if you include in the view an element that suggests the passage of time. Not only does this add an interesting dimension to an otherwise conventional landscape, but it also makes the permanence of the setting seem more impressive.

The two pictures here evoke a sense of the past in different ways. But both show how a carefully chosen subject can alter interpretations of landscape by creating a mood. The dilapidated automobile below is an interesting example of how the sturdiest man-made structures eventually become absorbed into the natural landscape. Disused roads and abandoned farm buildings also make good subjects and are powerful reminders of how quickly nature reclaims what is left untended. Because such features belong to recent history, they evoke a strong sense of nostalgia. The picture opposite uses living subjects to suggest the continuity of time – a traditional way of life in a setting that has remained unchanged.

Such images are most effective when the composition is kept simple. The viewpoint and lens you choose will depend on the type of subject. In the picture below, a close viewpoint and a wide-angle lens allowed the outmoded vehicle to dominate the landscape. The distant view at right suggests the isolation of the subjects in their vast surroundings.

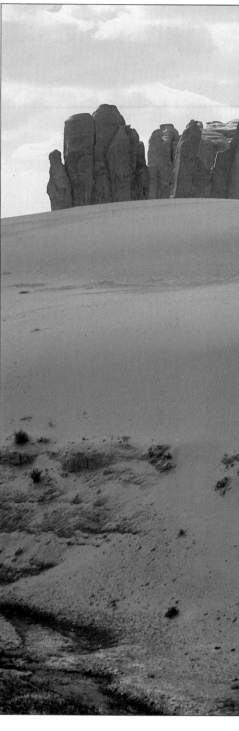

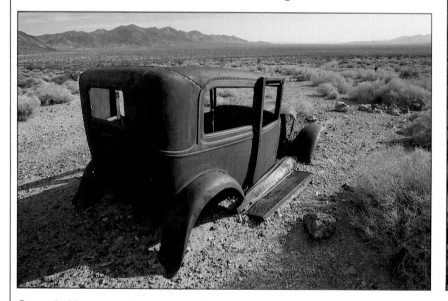

Corroded by rust, a long-abandoned automobile's earthy tones blend in with the natural colors of the landscape. The photographer used a 28mm lens to give the subject prominence against the stretching miles of desolate plains.

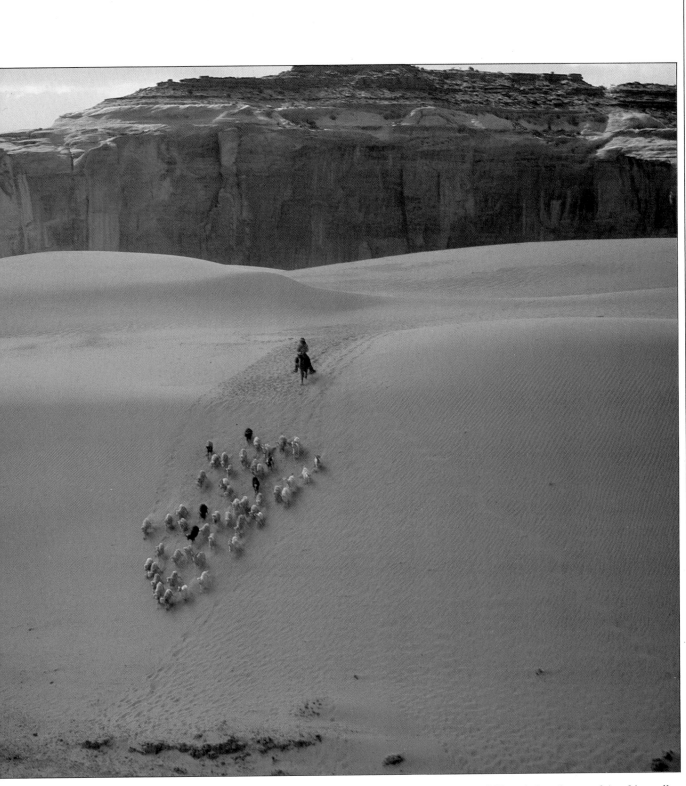

A Navajo herdsman drives his small flock across the sands of an Arizona valley to find fresh grazing. To obtain this evocative image of a bygone age, the photographer stood on an opposite ridge and waited for the subjects to descend.

29

Exploiting drama

Many landscapes suit a restrained, straightforward style of photography that allows the view to speak for itself without introducing any feeling of camera trickery. But some spectacular landforms or seascapes demand special photographic treatment to convey their full drama. Often, the solution is to take the boldest possible approach in lighting, lens choice and viewpoint, as in the pictures here.

With unusual rock shapes, try to show the outline more strongly than anything else. For example, use a telephoto lens to close in and frame the subject tightly, as in the picture at right. Then you could look for a way to silhouette the shapes against the sun, perhaps returning at the right time of day to make this possible. The two pictures on this page show how you can do this either by masking the sun or with the sun very low in the sky.

You can also use the special visual characteristics of lenses with focal lengths of less than 24mm or telephoto lenses with focal lengths of at least 200mm. Very wide-angle lenses distort the appearance of the subject, especially if you tilt the camera. Telephoto lenses compress perspective so dramatically that mountain peaks can be made to loom over foreground crags, as at the top of the opposite page.

Long telephoto lenses also let you take pictures from a greater distance, increasing the number of viewpoints available. For the picture at the bottom of the opposite page, the photographer found that the most dramatic view of the reef islet was from nearby cliffs rather than the much closer beach.

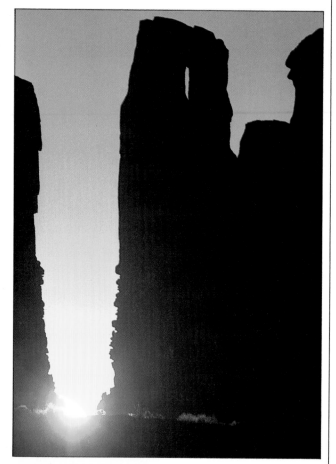

A stone pillar (above), silhouetted against the setting sun, illustrates the value of returning to a spot at different times of day. At noon the colors were insipid and the column looked dull, but the photographer came back and positioned himself to catch the silhouetted rock just as the sun sank between the pillars.

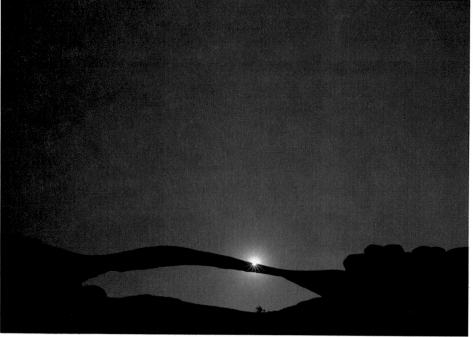

A rock arch (left) stands starkly against the sky in a view with an 18mm lens. To intensify the color to a deep indigo, the photographer used a polarizing filter and cut the exposure by two stops, thus creating an unusually dark and graphic image.

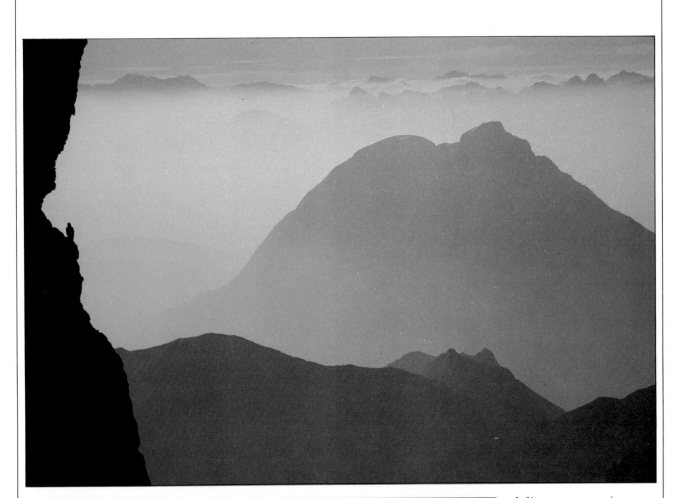

A distant mountain
*(above) rises through mist.
A 200 mm lens brought the
mountain closer and gave a
sense of scale, while an aperture
of f/16 kept the sheer rock
and perched bird in focus as
a powerful framing device.*

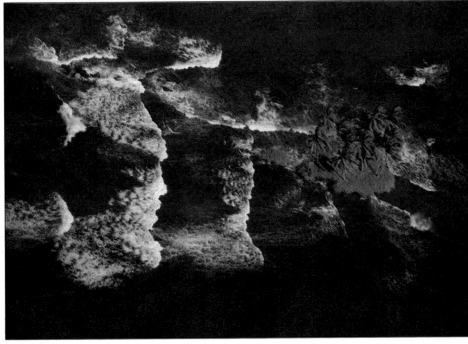

White waves *(left) wash
against a tiny island in this
unusual cliff-top view, while
the surrounding sea appears
almost black. The deliberate
underexposure enhanced the
feeling of bleakness, and a
200 mm lens closed in to
accentuate the dizzy feeling
of looking down from a height.*

31

Natural forces

Natural wonders such as hot springs, waterfalls and – most sensationally – erupting volcanoes have such visual drama that even a casual snapshot may result in an impressive picture. Yet you still need to apply the same thought and effort that you would give to less spectacular scenery. The pictures on these two pages show how much the use of color, pattern and good composition can intensify the impact of an already interesting subject.

In the picture below, the photographer used a 28mm lens to focus sharply on the colored algae of a hot spring in Yellowstone National Park, and to get so close that he could show the eerie darkness of the lower depths. By contrast, the picture alongside, of spurting lava, gains much of its power from the choice of a nighttime view, giving a strong pattern of red against black. The same photographer, Ernst Haas, also took the view of a dormant volcano on the opposite page, artfully timing his inclusion of a wispy cloud in the composition to suggest the fierce inner life that produced the stark black of the rough cinder slope. Color is again a key element in the waterfall picture at the bottom of the opposite page. Cover the red flower with your finger to see how much drama is lost without this carefully placed color accent.

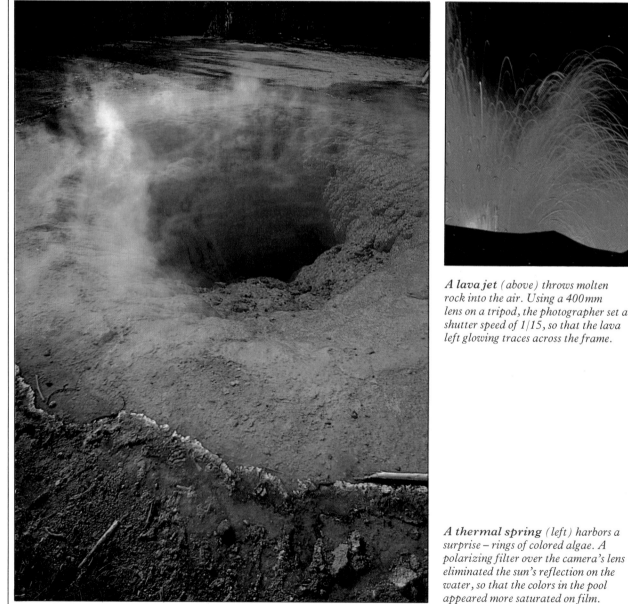

A lava jet (above) throws molten rock into the air. Using a 400mm lens on a tripod, the photographer set a shutter speed of 1/15, so that the lava left glowing traces across the frame.

A thermal spring (left) harbors a surprise – rings of colored algae. A polarizing filter over the camera's lens eliminated the sun's reflection on the water, so that the colors in the pool appeared more saturated on film.

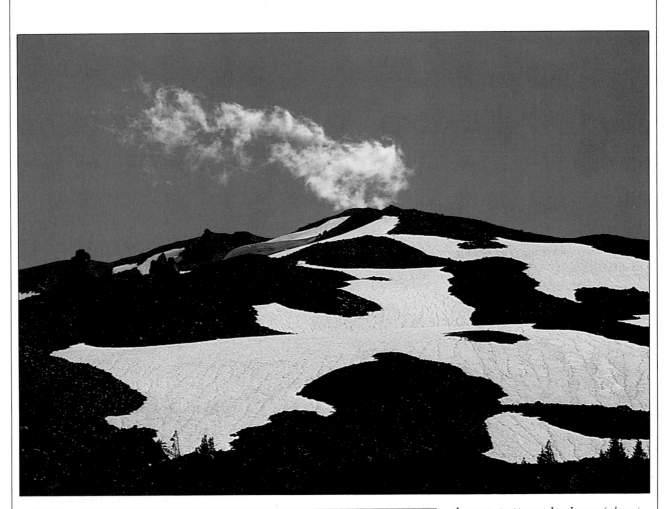

A snow-patterned volcano (above) *seems to puff steam as a passing cloud brushes its dormant summit. To record the high contrast between snow and cinder, the photographer took a meter reading from each area and averaged the results.*

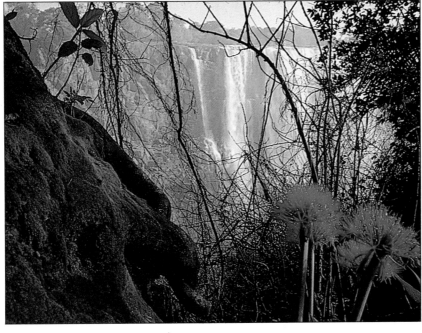

The enormous power of Victoria Falls, Zimbabwe, sends up a haze of drifting spray. A view through the lush vegetation on the cliffside gives scale and color to the image.

33

Expressing scale

The grandeur of an impressive landscape is much easier to appreciate when you are standing in front of it than when you are looking at it in a photograph. For example, at the edge of Venezuela's twin Hucha Falls, shown in the three pictures here, the waterfall would tower above you, while the thunderous roar of the water and the dampness of the drifting spray would help to give a vivid impression of the river's power. Yet even the largest and most striking of the photographic reproductions here reduces the waterfall to less than the size of a hand. And the picture below, in which the height of the cliffs is not easy to gauge, gives few clues to the dimensions.

To preserve an impression of size, you must ensure that photographs of such a scene contain some element that expresses scale. One way to do this is to include a familiar object in the picture. The most recognizable yardstick is a human figure; notice how the people in the boat bring the picture at near right to dramatic life.

If there is nothing familiar to indicate scale, you ·can help to suggest it by the choice of lens, composition or picture format. As shown on pages 20–21, a wide-angle lens and horizontal format can strengthen the sense of breadth. But if you want to suggest height, a long telephoto lens and an upright format usually work better, as in the photograph opposite. In this image, the impact is further enhanced by making a larger print, which in itself helps to convey grandeur, partly through sheer size and partly because a big image reveals texture and details invisible in a smaller picture.

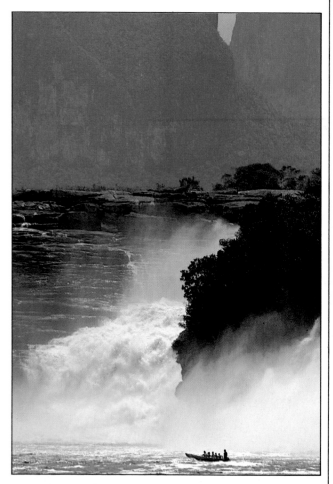

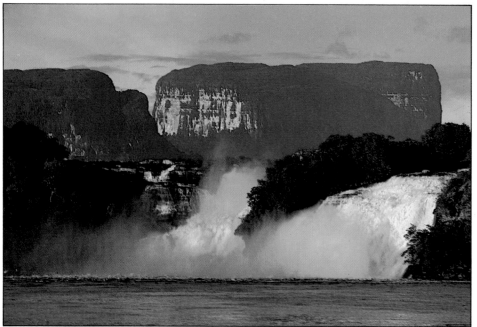

A small motorboat is dwarfed by the awesome size of the vast waterfalls. To dramatize the comparison, the photographer waited with a 135mm lens until the boat passed in front of the cloud of spray, so that the passengers stood out as silhouetted stick figures.

The twin falls (left) look less impressive at a distance through a normal lens, because while the broad view includes both channels, it makes each one seem smaller.

A cloud of spray (below) assumes a greater scale – and suggests the might of the whole waterfall – when the photographer closed in on the scene with a 200mm lens.

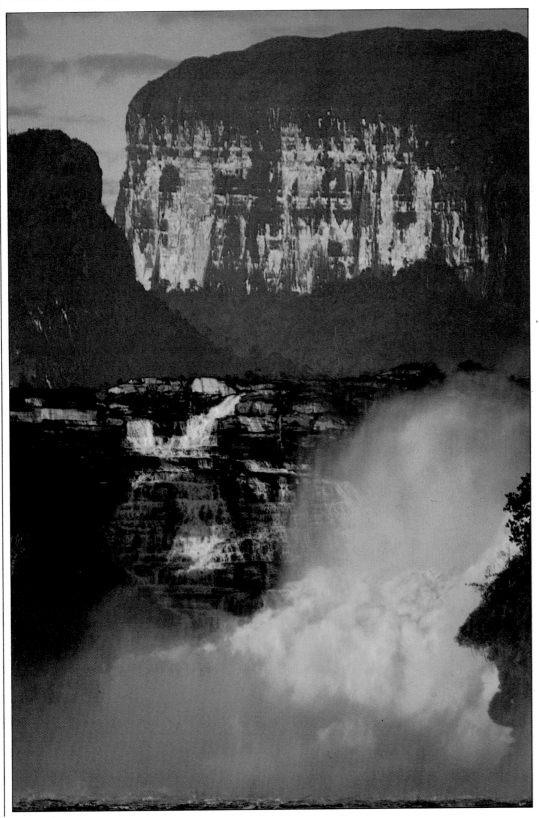

Patterns in nature

One way to give visual order to landscape pictures is to concentrate on images that have a strong element of pattern. The repetition inherent in the processes of nature provides a rich source of pattern, but you need to use close observations and appropriate angles of view to exploit this. For example, from many viewpoints pine trees present a visual jumble; it needed an alert eye and careful framing to achieve the rhythmic image of parallel trunks below.

Often a high viewpoint will reveal patterns invisible from ground level. The winding course of the river in the picture at the bottom of this page made a graphic image only when the photographer climbed to a vantage point above the valley.

Patterns will sometimes become more evident through a telephoto lens, as in the pictures on the opposite page. The lens both restricts the scene and flattens the perspective, thus helping to create juxtapositions of colors, shapes or lines that establish a sense of regularity.

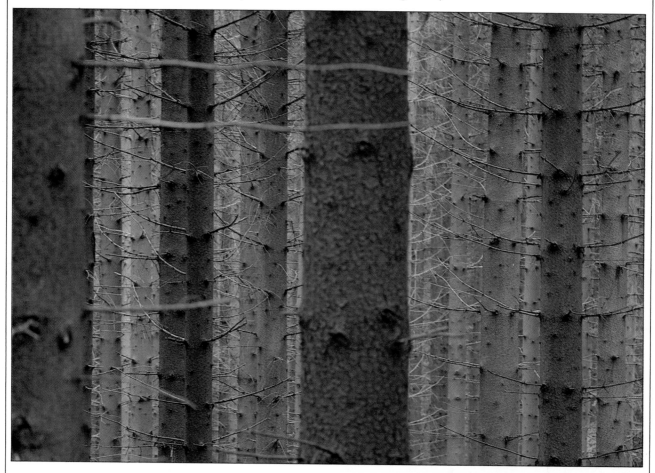

Pine trees form a barred pattern of trunks and twigs in soft browns and greens. The photographer carefully leveled the camera to ensure the perfect parallels.

A Sussex river catches the last of the afternoon light and glistens like quicksilver. Earlier in the day, when the sun was higher, the colors of water and land would have blended, masking the striking S shape.

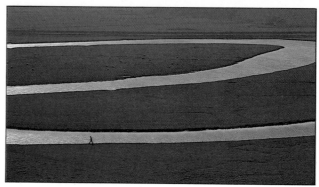

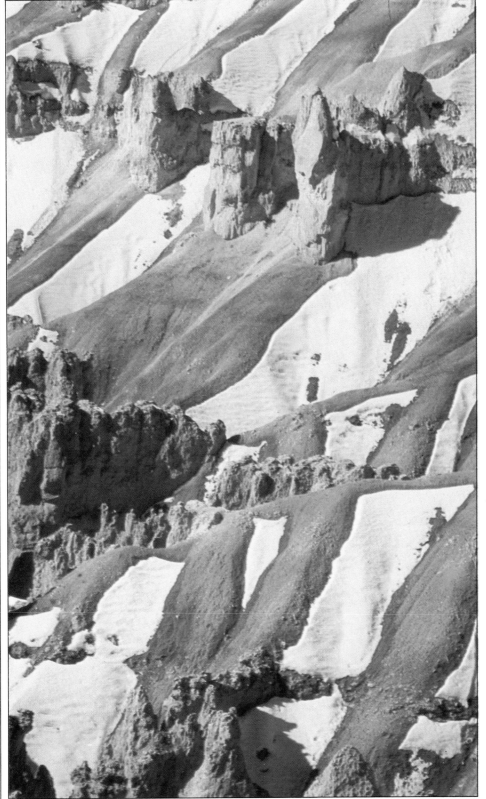

Melting snow *on a steep canyon wall accentuates a pattern of rock outcrops and eroded channels. To isolate this powerful image from a broader, less orderly view, the photographer used a 300mm telephoto lens.*

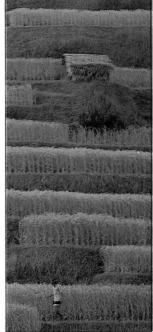

Ranks of tall, green rice *on an Indonesian hillside show the influence of man in patterning the landscape. The photographer included the brightly dressed figure to vary the monochromatic color scheme and contrast with the horizontal lines.*

Trees and forests/2

Woods and forests form distinctive landscapes in their own right and create complex environments that need different compositional approaches than those required to photograph a single tree.

First, look for a dominant point of interest. In a forest, a view that includes a tangle of branches, a mass of foliage and a variety of vegetation on the ground can easily appear as a disordered jumble. You may have to move around to find a unified image. The photographers who took the pictures shown here all chose different angles of view to convey specific impressions of woodland. The compositions are effective partly because of what they exclude. For example, in the picture below, a close viewpoint crops out the tops of the trees and

details at ground level to concentrate on the trunks and bright patches of sunlit leaves. This is a good approach where the trees grow closely together. For a more distant view, look for a clearing in the trees – a natural glade, a forest creek, or perhaps a firebreak. The photograph at top right captures the mood of a woodland scene even though the trees themselves are secondary to the path that leads the viewer into the frame.

If you cannot find a satisfying view at eye level, one alternative is to point the camera upward and frame the tops of trees. The patterns and colors of leafy branches will stand out strongly against a clear blue sky, particularly the glowing shades of autumn, as in the image at far right.

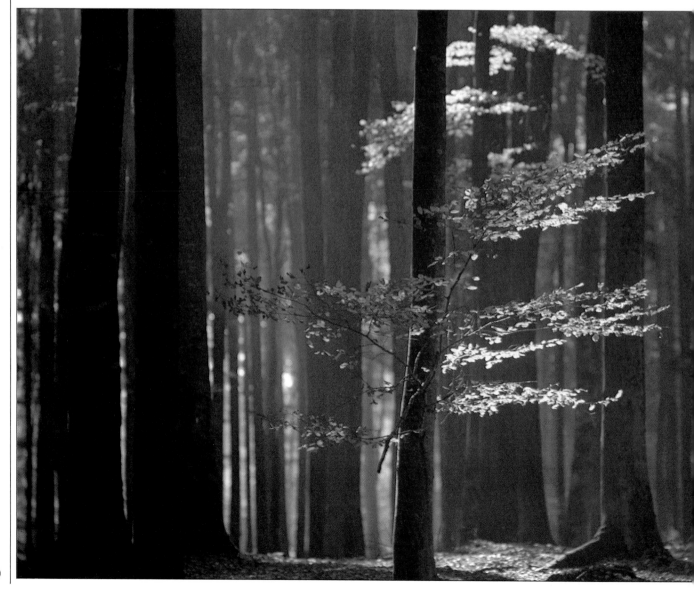

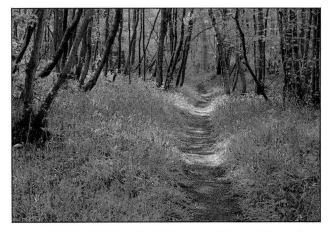

Dappled shade on a path winding through a carpet of bluebells creates an idyllic woodland scene. Trees leaning inward help to draw the eye to the center and beyond into the inviting distance. To retain detail in the shady areas, the photographer took an exposure reading from the foreground left-hand corner.

Sunlight filtering down to the forest floor (below) throws brilliant highlights on low, leafy branches. The photographer moved round the subject until the light was directly behind, and set a wide aperture to throw the surroundings out of focus.

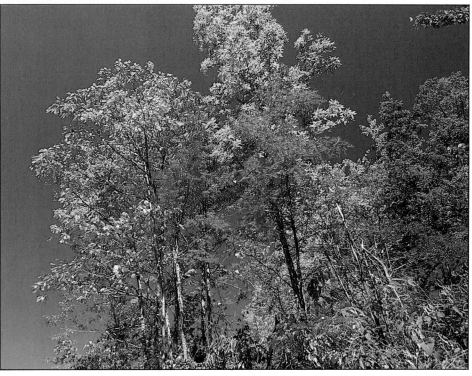

Autumn leaves blaze with color against a brilliant blue sky. To intensify the contrast and give good color saturation, the photographer used a polarizing filter, which darkened the sky and reduced the flare caused by light reflecting off the shiny leaf surfaces.

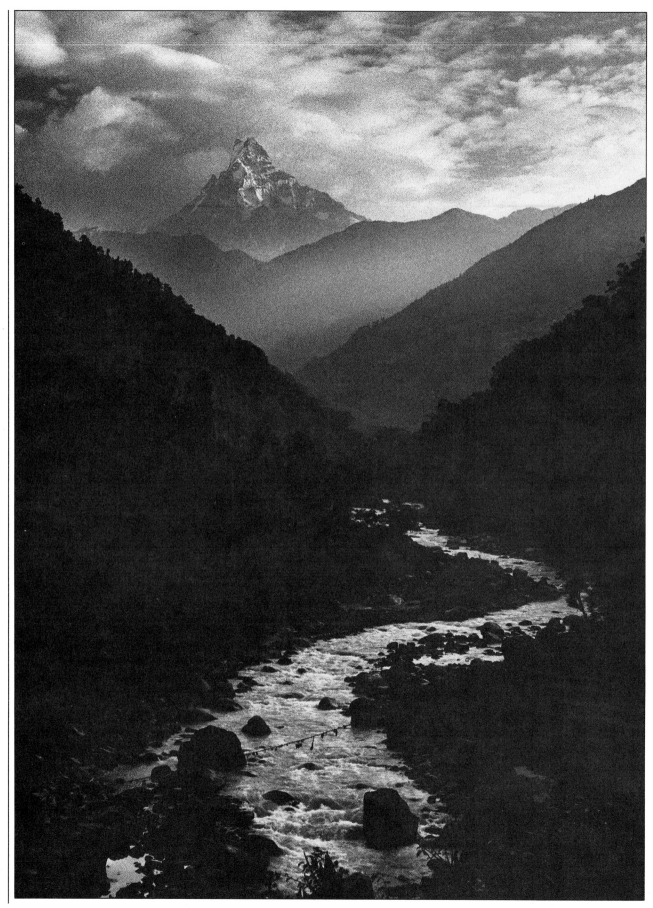

Mountain landscapes/1

Mountains make great landscape subjects by virtue of their scale and strong shapes alone. But they also have a majestic presence that irresistibly draws the eye, and the best mountain pictures capture something of this magnetic quality.

The most effective viewpoints for mountain photography are either very high or very low: from the middle slopes, the view upward or downward is much less imposing. From below, at some distance, you can often use the lead-up of a valley to get good views of an isolated peak or promontory rising above lesser slopes in solitary splendor. Alterna-

tively, choose a high viewpoint on a peak or ridge to obtain details of ice fields, rock formations, and atmospheric effects such as those shown below.

Reaching the best high viewpoints usually involves some walking and climbing, so limit your equipment to what you can carry with a backpack. Take a tripod so that you can use slow shutter speeds when you want to use small apertures for maximum depth of field. A wide-angle lens for panoramic views and a medium telephoto lens to pick out details are useful but not essential: both pictures shown here were taken with a normal lens.

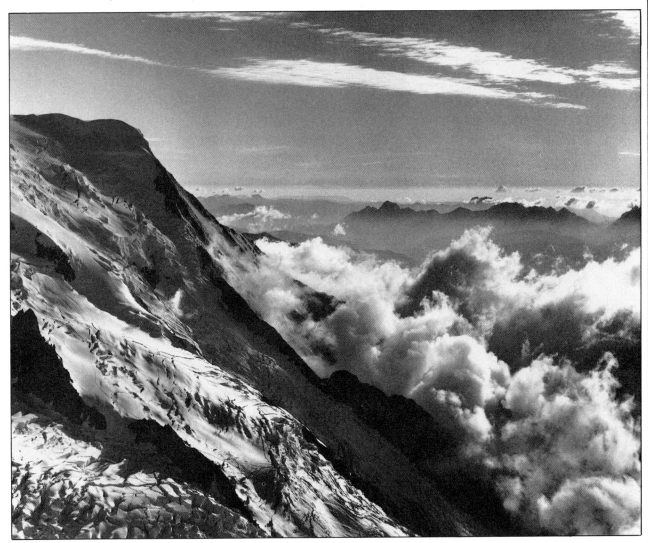

Meltwater (left) courses down a valley dominated by a soaring pinnacle of the Annapurna massif in Nepal. Every element in the composition – the water, the sloping valleys and the low clouds – leads the eye toward the icy magnificence of the peak.

Clouds drift over the northern slopes of Mont Blanc, in the French Alps. The photographer framed the scene to show the details of shattered glacier ice in the foreground as well as to convey the cold grandeur of the view.

Mountain landscapes/2

Every mountain region has its own distinctive character, and you can make interesting pictures by taking a broad, encompassing viewpoint that shows a whole environment or relates a zone of vegetation to the bleaker ground above. Often the scenery will alter dramatically from one zone to the next as you climb higher. In tropical regions, there may be many scenic zones, from rain forests upward. In harsh northern climates, even the lower slopes may be too cold and wet for forest, so there is an abrupt transition from brushwood to bare rock.

The picture below, taken in New Zealand, shows how a close foreground view of even a plain expanse of scrub can add scale and contrast to a range of hills. In the similar New Zealand scene at the bottom of the opposite page, the same photographer was able to exploit the strange lighting effect before a storm to accentuate the colors and patterns of the landscape. If lighting conditions are less spectacular, try to find some element in the foreground to provide a focus of interest – perhaps a twisted, stunted tree or a small lake.

In higher mountain country, distant views of the peaks help to convey the dramatic shifts from one level of vegetation to the next. In the picture at far right, for example, overhanging branches provide a frame for the broken ridge behind and a contrast to its bleached, barren structure. Among the high peaks, it is often the sheer expanse of featureless snow and ice that conveys the bleak mood of the environment, and if the sun is overhead pictures can lack contrast and scale. To counter this, take your pictures early or late in the day when the sun creates shadows and highlights on the ice.

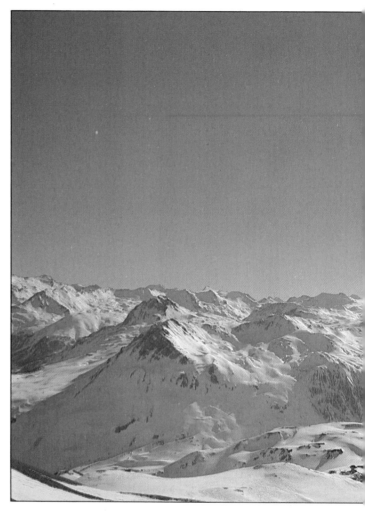

The flaring rays of a low sun (above) reveal the clarity of an alpine summit near Tignes in France. The photographer removed his protective UV filter to avoid the double image that could otherwise result from pointing the camera into the sun.

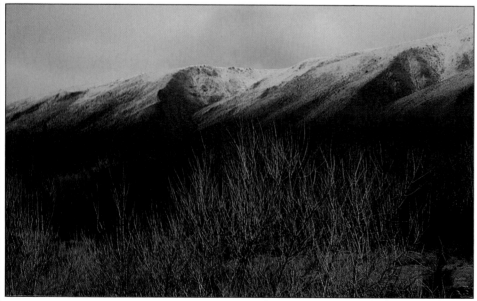

Spiky brushwood gives way to somber slopes dusted with snow. A close view of the bare twigs and poor soil emphasized the rugged high-country setting.

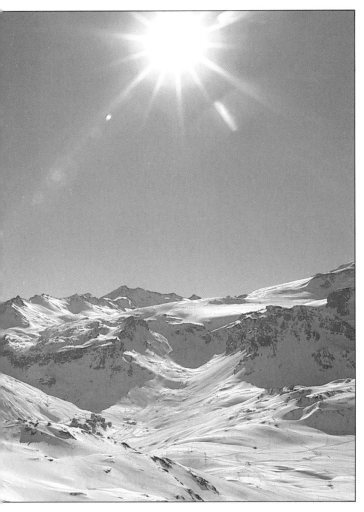

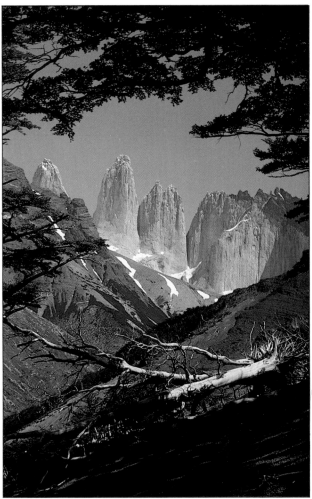

A fallen tree and leafy branches (above) give greater dimension to a view of the Andes. The contrast between the shady foreground, with its patchy vegetation, and the stark white crags against a clear sky conveys the rapid scenery changes typical of high mountain regions.

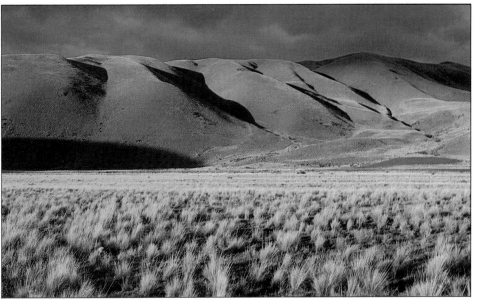

Sunlight breaking through a stormy sky (left) deepens the dull gold of tussock grass and gently undulating hills. Long shadows on the slopes and a splash of green help to break up the uniform tones of the landscape.

Barren ground

Inhospitable though they may be to life, deserts are among the most exciting locations for landscape photography. Their starkness gives them the key photographic quality of simplicity, making possible images of hard-edged, graphic and even abstract quality – landscapes stripped down to the bare essentials of sky, sand and rock.

However, lunar-like pictures such as the one below will not fall easily into your lap. Most desert regions have expanses of uninteresting scrub or stony rubble. Often, you have to know exactly where to find the comparatively small areas that offer good pictures. So if you want to avoid the discomfort of trekking through unrewarding wastelands, research the potential sites before setting out for the day's photography.

Lighting conditions are particularly important in desert photography. The more flat and featureless the area, the less likely you are to get good pictures under a high midday sun. In the picture of dried bones at the bottom of the opposite page, the photographer found a dramatic solution. More commonly, you will need to time your photography so that a lower sun brings out the shapes of rocks or dunes. Early morning and late afternoon are also cooler and easier to work in. The vivid sunsets common in desert regions make twilight pictures especially effective; the silhouetted desert plants on the opposite page would have had less mystery under the all-revealing glare of a high sun.

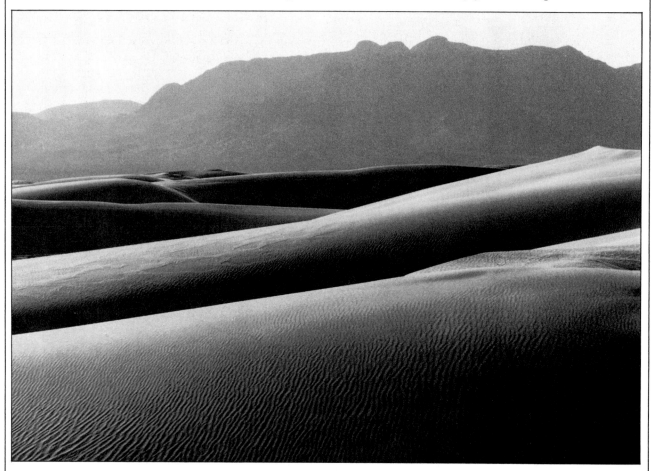

Rolling dunes *at White Sands, New Mexico, stand out as bold shapes in the slanting light of early morning. Because of the reflective brightness of the sand, the photographer gave one stop more exposure than the camera's meter had indicated – the same technique used to prevent underexposing snow scenes.*

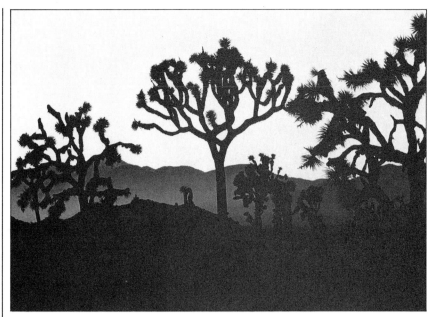

Joshua trees (left) reveal their weird shapes against the evening sky. On ISO 64 film, 1/60 at f/5.6 gave the dramatic, underexposed effect.

A crazy paving of cracked mud (below) stretches across the floor of Lake El Mirage, California. A 24mm wide-angle lens from a low viewpoint created the distortion and ensured that the whole image was sharply focused at f/11.

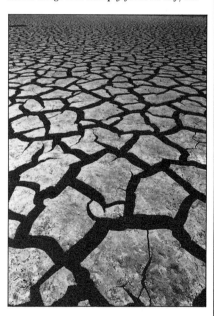

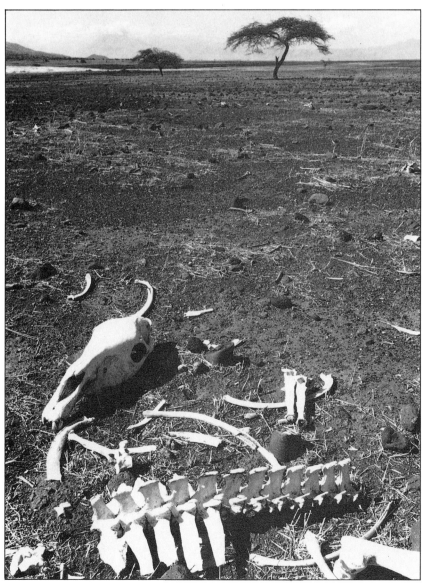

Dry animal bones lie bleached and scattered on an arid African plain. The photographer found nothing else of interest in the empty landscape. He used a 28mm wide-angle lens so as to concentrate on the bones as the foreground of a composition that stresses a sense of space and distance.

Sea and shore/1

On a calm, overcast day, the sea and wet sand reflect the sky's soft shades of gray and hint at colors that are muted, never brash and brilliant. Often, such cloudy weather seems unpromising for photography. But color film has a remarkable ability to record subtle differences of color. Sometimes this produces scenes tinted with exquisitely delicate hues, particularly at dawn and dusk when sky and sea or sand change through shades of pink and blue, as they do in the picture below. Avoid underexposure in cloudy conditions, or the sea will look dull and leaden. If anything, a little extra exposure is best, to capture the pastel hues.

Sunlight shows the sea in another mood, picking out deeper, richer colors and touching the breakers with brilliant white crests. On a sunny day, pay special attention to the movement of clouds. When they cross the sun, clouds can throw deep shadows on the sea, producing dark horizons that form a dramatic contrast with the color of sunlit water closer to the shore, as in the image at right. To prevent errors of exposure in such a high-contrast scene, take a meter reading from a midtone – the area between the horizon and the breaking waves in the example shown here.

In blustery weather, you can get good pictures near rocks, where the sea throws up jets of spray, especially if you stand so that the waves are backlit, as in the picture at the bottom of this page. If you can get close enough, a wide-angle lens makes the scene look even more dramatic, but take care that spray does not splash your camera. Wipe away the corrosive salt-water before it dries, and always keep the lens covered with a skylight filter.

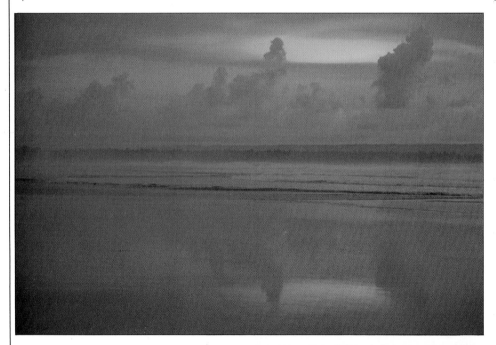

A cloudy seascape (left) turns pink and turquoise as the sun rises. The receding waves left the beach wet, and the photographer used the sheen of the water to mirror the colors of the early-morning sky.

A wide sea (right) threatened to soak the photographer when he took this picture, so he moved back from the shore and used a 135 mm telephoto lens to frame the waves against the orange light of dusk.

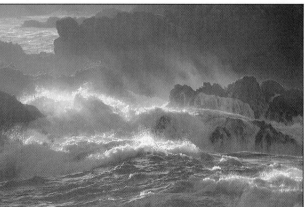

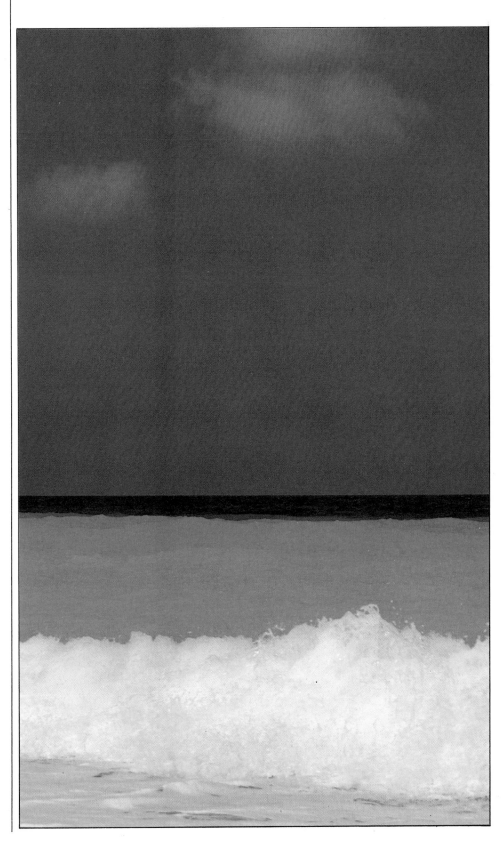

A white breaker *crashes onto the beach, adding a froth of white to the blues of sea and sky. A polarizing filter helped make the colors deeper.*

Sea and shore/2

Much of the attraction of coastal scenery lies in the vigorous interplay between sea and land – irresistible force meeting immovable object. Waves, wind and tide change the appearance of a single scene from minute to minute, making this the most active of all landscapes to photograph. But coastlines vary enormously, as shown by the three views here, all taken in the south-west of England. You should look for images that not only express movement but also reveal the particular character of the location.

Rocky coastlines provide dramatic images such as those on this page. Both photographers here chose angles of view that express the height and ruggedness of the wave-battered rocks. For this type of effect, you can use a wide-angle lens from a position close to the foot of a cliff, to show its full extent looming above. You can also find vantage points on the tops of cliffs from which to photograph the combination of headlands and the vastness of the sea beyond. A wide-angle lens will include the cliff and

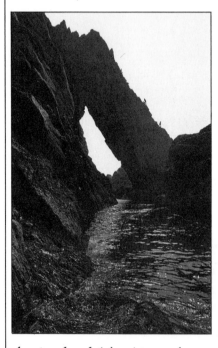

A natural arch (above) *towers above a tiny cove lapped by an oily sea. The photographer saw the antlike climbers silhouetted against the sky and used a 35mm wide-angle lens to include the seaweed-covered foreground. To record the dark tone of the rock faithfully, he gave one stop less exposure than the camera's meter indicated.*

A weathered headland (right) *juts into the ocean. A 24mm wide-angle lens, aimed slightly downward, gave a broad enough scope to include lichen-stained rocks close to the camera, waves beating the shore below and the line of the cliff beyond. A small aperture of f/16 kept all three elements in sharp focus.*

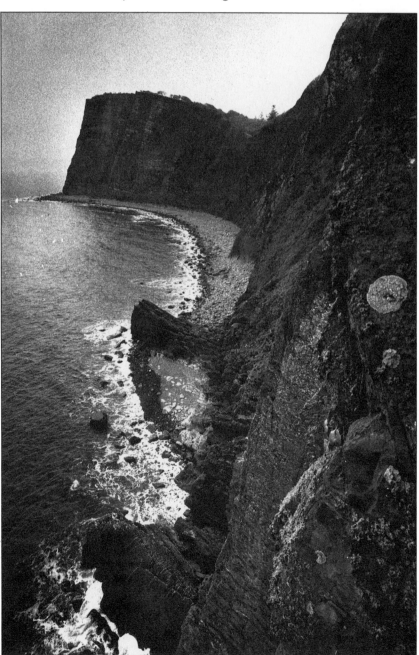

rocks close to the camera. Alternatively, a telephoto lens lets you show successive cliffs bunched together as they stretch into the distance.

For flat estuaries, a wide-angle lens may be best, to take in both the shallow waters lapping on the shore in the foreground and a broad sky behind. In the picture immediately below, the photographer used leaning trees and figures, slightly distorted by a wide-angle lens, to convey the mood and character of a windswept vacation resort.

A windblown tree bends permanently inland. To silhouette this expressive feature and clearly show the detail in the scurrying clouds, the photographer gave one and a half stops less exposure than the meter suggested, keeping the setting sun just out of the frame. He also tilted the camera upward, using a 24mm lens, which produced converging verticals at the edge of the frame so that the walkers appear to lean with the wind.

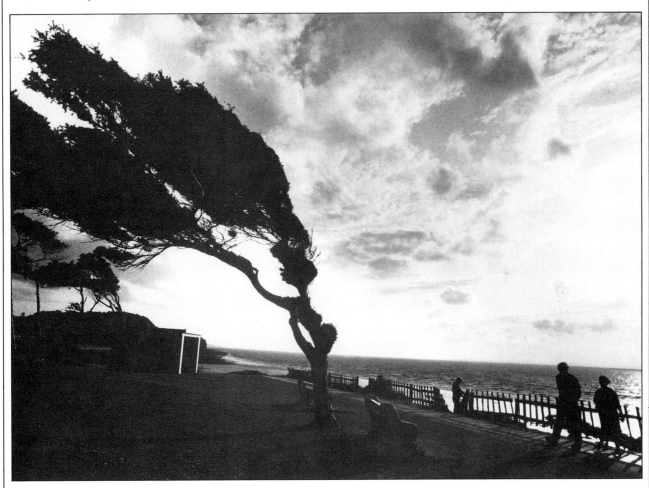

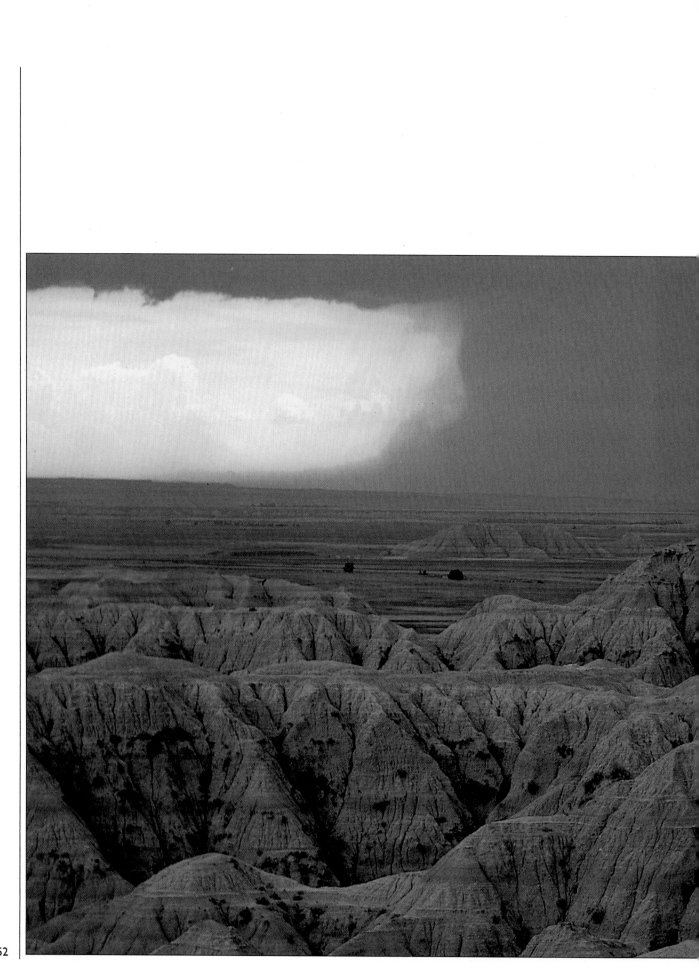

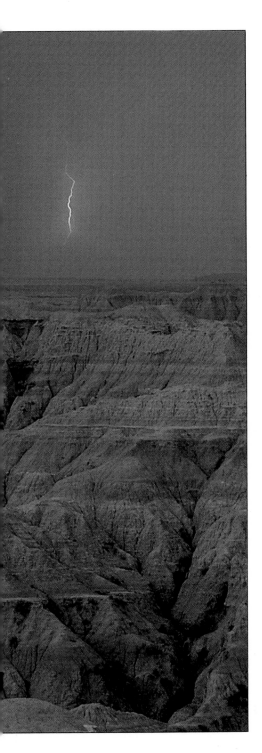

LANDSCAPE AND WEATHER

Landscape pictures need not be static. The light falling on the land constantly changes, and the atmospheric effects of weather can transform a scene from hour to hour. In addition, the major climatic changes of the seasons completely alter the countryside, demanding different photographic techniques and approaches. It is one thing to be able to represent accurately the whiteness of snow and another to find an image that expresses the crackling crispness of freezing air and vegetation. Capturing the process of change and conveying the precise mood of particular weather conditions present two of landscape photography's most exciting challenges.

This section concentrates on techniques that can help you use transient effects of weather and light to take good pictures in conditions that often persuade photographers to put away their cameras. For example, the view at left shows a barren landscape that has become as weird as the surface of a distant planet because of the mysteriously charged atmosphere of an electrical storm – an effect that the photographer has exploited to perfection.

Storm breaks over the badlands of South Dakota. To catch the momentary flashes of distant lightning, the photographer put the camera on a tripod for a series of 1-second exposures, selecting the result that caught the best flash. He used slow film and cut down the light with a small aperture of f/22 and a neutral density filter.

The best light

For a couple of hours after dawn and before dusk, the sun's light slants low over the land. This is the best time to photograph the landscape, because the rays of sun pick out relief and contour, creating long shadows across the scene. And because the light changes more rapidly early and late in the day than it does around noon, it is possible to show the landscape in several quite different moods, all in the space of half an hour or so.

As the pictures at far right show, photographing the same scene in both morning and evening gives an even greater variety because, at either end of the day, the sunlight comes from approximately opposite directions. Late afternoon is usually a more convenient time to take pictures, particularly if you have some distance to travel to reach your chosen

location. On the other hand, the early morning offers you the advantage of solitude – important if you want an empty view of a popular scenic spot, such as the unusual rock outcrop shown below.

As the sun rises or sets, it is often difficult to decide the best moment at which to take the picture. Near sunset, the temptation is to wait for the very last rays of daylight. However, the sun dis-appears quite suddenly, and if the scene is good and you have enough film, it is best to take a series of pictures at intervals of several minutes. Maintain a single exposure setting, or use the exposure lock button on an automatic camera. Otherwise, your camera may adjust the exposure to compensate for the changing light level, and thus produce a series of almost identical pictures.

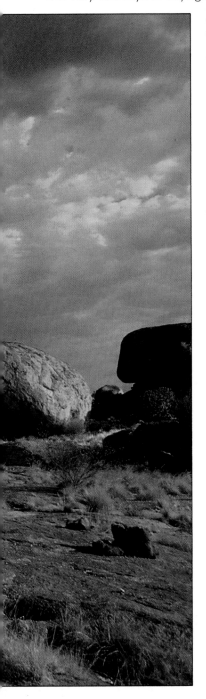

Huge boulders (left) are lit almost theatrically to show their form and mass in a scene in Australia's Northern Territory. The picture's intensity comes from slanting early-morning sun trapped beneath the storm clouds.

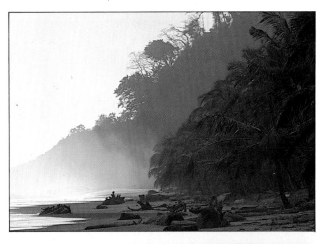

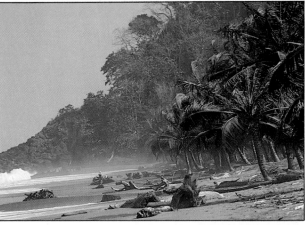

A tropical beach at dawn (top right), noon and dusk (bottom) shows how changing light can markedly alter the same view. At sunrise the beach is still in shadow, so the scene appears somber and cold. Midday light produced a descriptive but ordinary picture, because the high sun cast an even light on the beach, the driftwood and the trees. Sunset threw a more interesting low light across the sand, picking out the logs with soft rays.

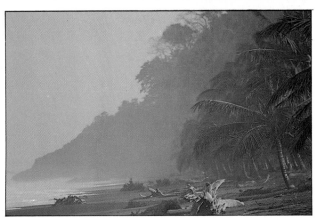

Clouds and skies

The sky makes a vital contribution to a landscape. Even a quite ordinary sky adds spaciousness or a sense of infinite distance. A spectacular sky does more; it transforms the picture with brilliant color, or with the myriad patterns and textures of clouds.

You can emphasize an interesting sky simply by tilting the camera upward, so that the horizon is close to the bottom of the frame. When the sky is very bright, the land beneath will appear in silhouette, as in the picture below at right. If you want to retain rich colors in both land and sky, as the photographer has done in the picture below at left, try to ensure that the two areas are of approxi-mately equal brightness. Usually, this means using a filter to darken the generally lighter sky area. You can make blue skies darker in tone with a polarizing filter. However, this filter will not affect pale skies, for which you need a gray graduated filter, as explained in the box at far right.

Occasionally, particularly after a storm, the sky puts on an awe-inspiring display of color and light. At these rare times, it may be worth leaving the land out of the frame in favor of a cloudscape such as that shown at right. For the best results, close in on individual cloud formations with a telephoto lens and underexpose to record fully saturated colors.

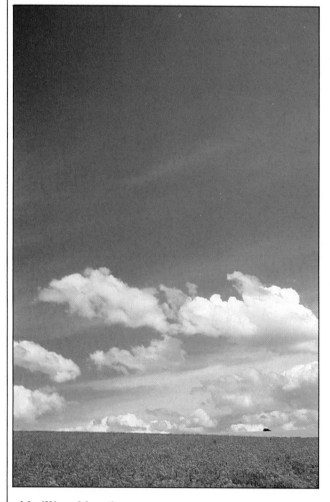

A brilliant blue sky and fluffy cloud formations gain extra impact from the photographer's choice of foreground and balancing of the two elements. A polarizing filter enriched the colors of both the sky and the poppies.

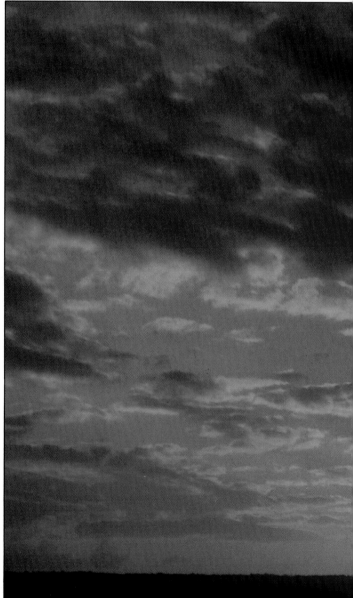

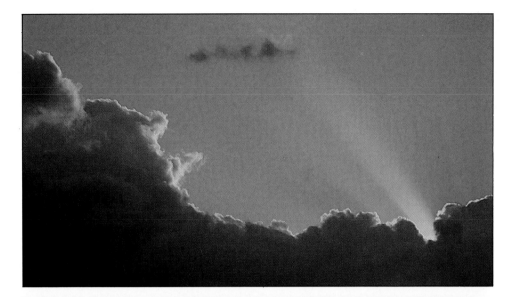

Storm clouds *focus the sun's rays into a single shaft – and a 200mm lens picks out the sunbeam and the sun-tipped clouds from the surrounding sky.*

Graduated filters
To make the sky darker without affecting the landscape beneath, use a gray graduated filter. Such a filter is gray at the top and clear at the bottom, with the dark and light areas merging very gradually together in the middle. If this transitional area is positioned near the horizon, the sky tone darkens considerably, and it is very hard to tell that a filter has been used at all.

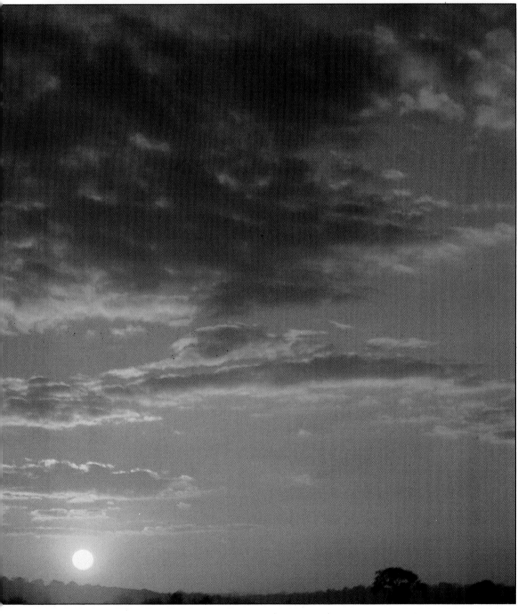

A rural sunset *gilds the sky, lighting the clouds from below. To cope with the wide brightness range of the sky, the photographer made exposures at a number of different apertures and then selected the best.*

Sky and wind

In blustery weather the clouds sweep quickly across the sky and their shadows cast a moving pattern of light and dark over the landscape, so that the scene changes minute by minute. A viewpoint high enough to enable you to look out over the shapes of hills and valleys helps to reveal the patches of light in the most graphic way, as in the picture below.

As a general rule, set the exposure to suit the sunlit portion of these scenes. To do this, wait until a patch of light passes over your camera position, then take a meter reading from the ground nearby. This should give you the correct reading for the overall view.

Grass, water or trees in front of the camera will all show the effects of wind. A fast shutter speed, such as 1/250, freezes movement if you want an absolutely sharp image, but often slight blurring gives a more vivid impression of a windy day, as does the tree in the image below. If the light is very strong, you may need to use a neutral density (gray) filter to reduce the brightness so that you can select a shutter speed slow enough to produce the degree of blurring you want.

Often, windy weather breaks up heavy clouds into distinctive patterns, such as those shown on the opposite page. Broken clouds also offer good chances to take dramatic pictures of the sun, which is usually too bright to be photographed directly, especially with a telephoto lens, unless it is low in the sky veiled by clouds.

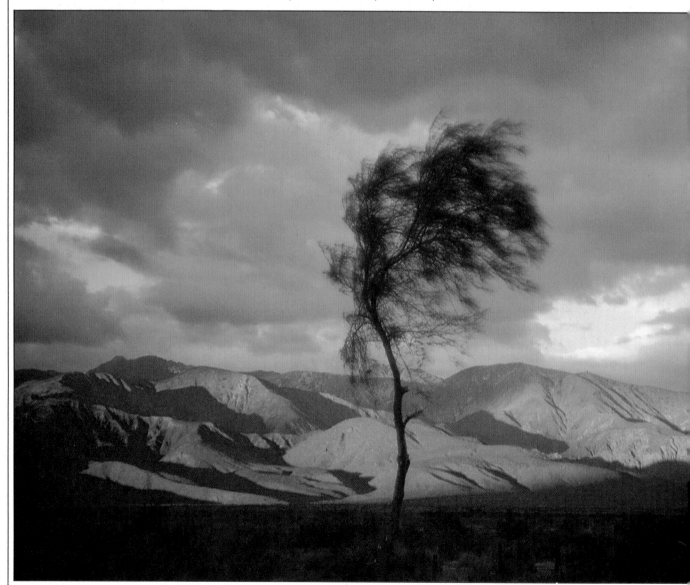

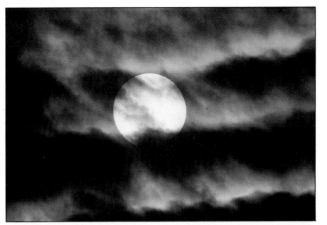

A swaying tree conveys expressively the violence of the wind. To blur the tree's outline, the photographer set a minimum aperture of f/22, which allowed the use of a shutter speed of 1/15 – slow enough to show considerable movement.

The sun (left), enlarged by a 400mm lens, shines through scudding clouds. At this degree of magnification, and without the clouds to moderate the rays, the sun would have been much too bright to photograph without a filter.

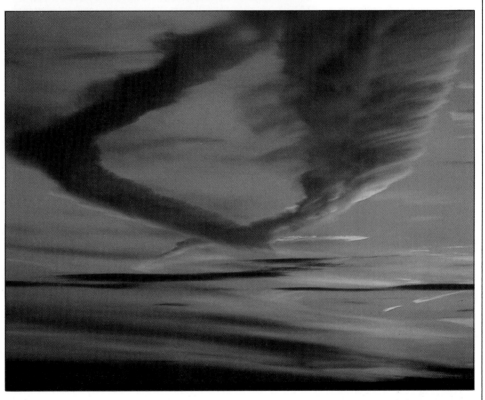

Golden clouds, blown by the wind, create a pattern of whorled lines that sweep the eye into the distance. The photographer waited until just after sunset before taking the picture, so that the clouds are lit from below – but the sun itself is hidden.

Twilight and night

The brief period of twilight that follows dusk is an enchanting time to take pictures. Twilight photographs have all the special, calm beauty of night, yet there is still enough light in the sky at this time to make photography quite easy.

Following an afternoon of clear sky, twilight is a rich blue, sometimes tinged with the pink of sunset. For the deepest, richest colors, take a meter reading from the sky itself. However, this will record the foreground as a silhouette, and you will need to open up the lens by a stop or two if you want to retain a little detail in the land, as in the image of the tree on the opposite page. If you can include a lake, the sea or a broad river in the scene, the water's surface will help to spread the colors of the sky across the whole picture. This is the technique used to create the beautiful image shown below.

At night, the brightest moonlight is very much weaker than sunlight. Even with Kodacolor VR 400 film, a moonlit landscape will probably need an exposure of about four seconds at f/2 unless there is a large expanse of reflective water or snow in the picture. Bracket your exposures, and use a tripod to avoid camera shake.

One way to cope with the dim conditions of night is to include the bright surface of the moon itself in the picture, as in the images on the opposite page at left and at bottom. Such photographs are most effective when the sky is still quite light in relation to the moon – shortly after sunset – and when the moon is at least half full. Check a local newspaper for the times of moonrise and sunset.

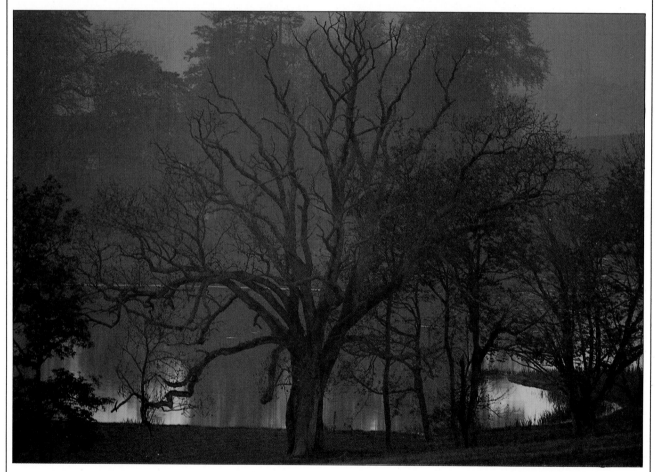

A still pond in winter reflects the subtle shades of twilight. Just after the sun had set, the light was still bright enough to permit an exposure of 1/8 at f/8 on ISO 64 film.

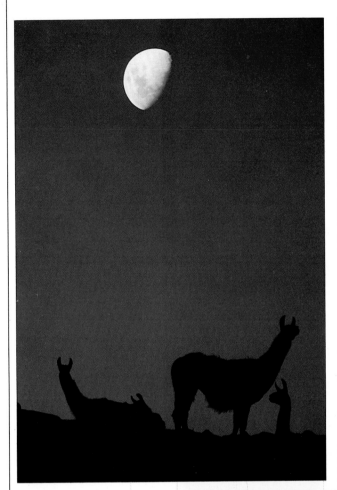

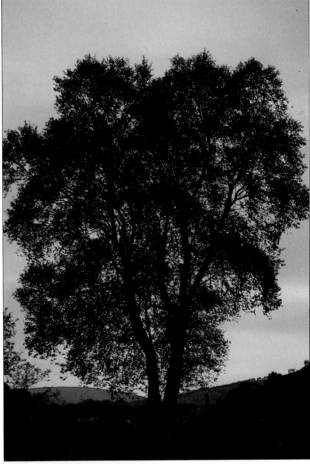

Llamas in Peru (above) stand motionless during a 1/4-second exposure. A slower shutter speed would have made the sky brighter, but would have introduced the risk of the moon blurring due to its motion.

Moonlit clouds (right) dapple the night sky with silver and black. By pointing the camera at the moon, the photographer was able to set a shutter speed of 1/60 and thus handhold the camera.

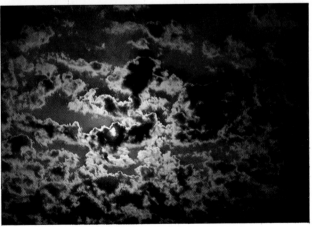

A rosy sky (above) forms a colorful backdrop for a leafy beech tree. To ensure that the distant hills did not appear as featureless silhouettes, the photographer gave one stop more exposure than his light meter indicated (ISO 400, 1/4 at f/4).

Rain and mist

The gentle softening of shapes, tones and colors created by water vapor in the air makes wonderfully evocative landscape pictures. For mist, the most likely time is dawn, particularly in early winter when in many areas low vapor hangs over water, marshland, damp fields and enclosed valleys. If you rise early enough to catch the first rays of the sun slanting across the landscape, the play of light on the mist can create particularly beautiful effects. As in the picture at the bottom of the opposite page, try to find a viewpoint from higher ground where the air is clearer and you can look down on the mist as it flows around islands of trees and hills.

When the light is dim, as in the photograph below, or when the mist is thick, look for a composition based on simple, broad areas of tone. Colors will be very muted, so concentrate on the balance between light and dark – ideally, a few strong dark areas emerging from a soft blackground. Unless you want a dark, moody effect, give one-half-to one stop extra exposure to preserve the pale effect of mist when dark areas are small in the frame.

Under a heavy blanket of clouds, poor visibility and low light may make it difficult to find worthwhile scenes to photograph. Contrast will be reduced and the scene may look gloomy and featureless. But watch for the moments of visual drama when light breaks through gaps in the clouds. At these times, rain itself can become a subject, as in the example at the top of the opposite page. Here, the photographer has caught the light glinting on drops of rain as they streak past an open window.

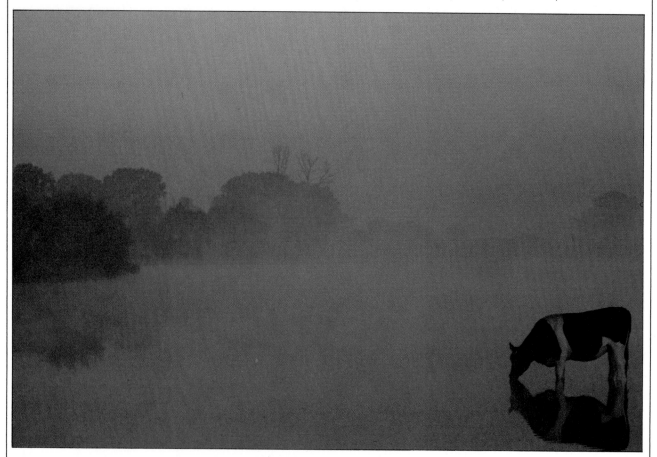

A lone cow stands in a flooded meadow. To keep the somber purple of the dawn light, the photographer followed the camera's meter and set the controls at 1/60 and f/4 with ISO 64 film.

Heavy rain pelts past
a window, shining brightly
in a ray of sun that has
broken through the clouds.
A slow shutter speed of 1/30
showed the rain as streaks
against the bright pink
flowers of the garden behind.

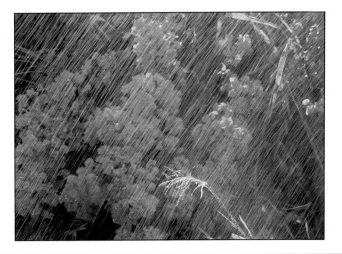

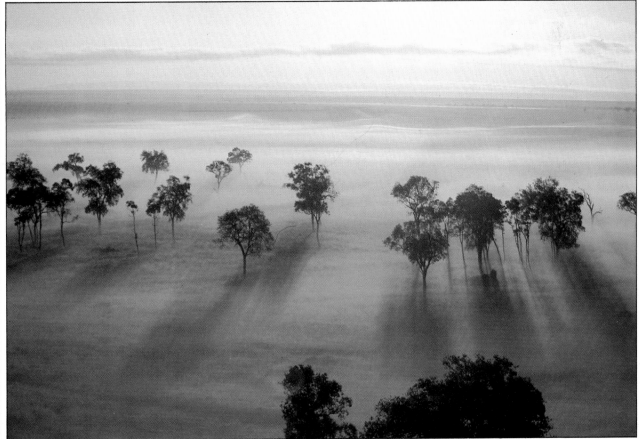

A pale mist lying over
a damp plain begins to
disperse. An exposure of
1/125 at f/5.6 caught the
fleeting effect, framed by
an 80mm lens from the high
viewpoint of a hill.

Ice and snow

The pictures on these two pages show that freezing cold has its own visual drama and that the silent, still enclosed feeling of a midwinter's day can come through strongly in photographs. Although colors often vanish and the scene is reduced to monochromatic patterns of just three or four tones, this often helps to simplify landscapes that would otherwise be too complex. The frozen pond and woodland below gain coherence and impact in this way.

However, the subtle whites of frost or snow demand a delicate touch, especially in judging exposure. A mere half-stop may make the difference between an effective picture and an underexposed image that comes out gray, or an overexposed one

that comes out bleached. On a day when sky and land merge in a unifying whiteness, underexposure is the more likely risk, because your meter will be compensating for the absence of darker tones. Start by allowing one stop more than the camera's meter indicates for a frost-covered scene, and one and a half stops extra for snow. Then bracket in half-stops on either side of this setting.

You can create impressions of brittle coldness with details just as convincingly as with broader views, as the pictures on the opposite page show. Look for details that provide a strong contrast of white against black or in which frost creates interesting patterns and textures.

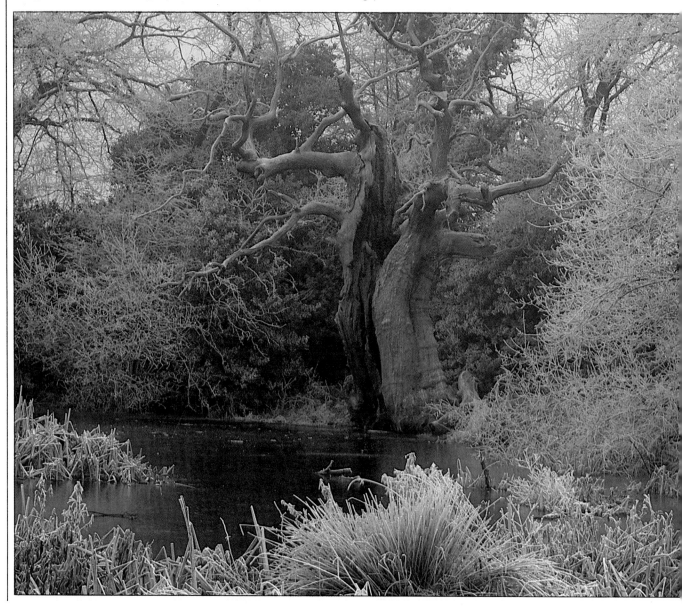

Hoar-frost *(below) covers the trees and grass around a frozen pond. To be sure of conveying the icy cold of the morning, the photographer bracketed the exposures. One and a half stops more than the meter indicated gave the best result.*

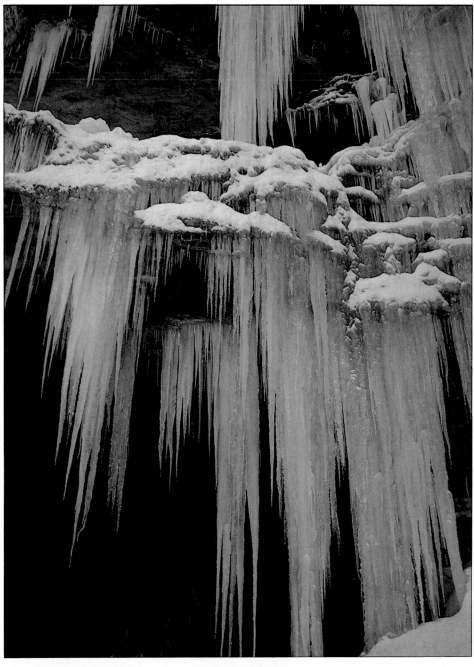

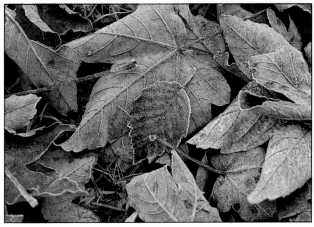

Sparkling icicles *(above) hang in sheets from a rock face usually dripping with water. Because of the amount of deep shadow in the frame, the photographer did not need to allow extra exposure to record the snow's whiteness.*

Frosty leaves *(left) create subtle textures and colors. The photographer closed in with a 50mm normal lens at its close-focusing limit and gave a half-stop more than the camera's meter suggested.*

The glare of the sun

On a sunny day, every shiny surface can reflect a brilliant image of the sun's light. The surfaces of water, sand, stones, blades of grass or glossy leaves all can form bright reflections that dilute and desaturate color. And the glare of direct sunlight may make the sky itself look less blue. In these conditions, the best way to restore colors in your pictures is to use a polarizing filter.

Cutting glare can make the colors of foliage, fruit and flowers seem astonishingly vivid, as in the picture below. Against a sky darkened by a polarizing filter, even landscape features seem to be much brighter, as in the picture of crags on the opposite page at left. Keep the filter close at hand, so that you can check how it will affect the scene in front of you. You can use the filter alone to do this – just rotate it while looking through it.

However, removing glare is not always the best way to improve a picture. Occasionally, you can create a striking effect by pointing the camera almost directly at the sun, as the photographer did for the picture on the opposite page at right, taken from an airplane. Stop the lens down to a small aperture, and take pictures at several different shutter settings to be sure of getting at least one that is perfectly exposed.

Clusters of rich, red berries
contrast brilliantly with the blue sky behind. To ensure full color saturation, the photographer used a polarizing filter. The camera's meter compensated for the light absorbed by the filter, setting an exposure of 1/60 at f/8.

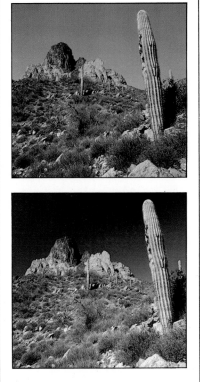

Using a polarizing filter
Glare in the unfiltered picture (top) is blocked by a polarizing filter that darkened the sky in the second picture. Colors are most affected when the sun is to one side of the camera and low, as it was here. The polarizing filter shown on the camera above has a white indicator that you align with the sun to find the point at which the filter will most effectively block out any polarized light.

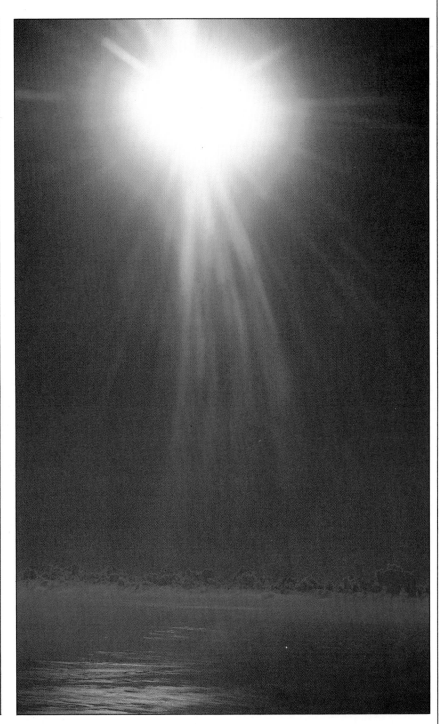

The sun's rays strike the smeared surface of an airplane window, creating a brilliant splash of light at the top of this seascape. Pointing the camera at the clouds while taking the meter reading prevented the sun from totally dominating the exposure.

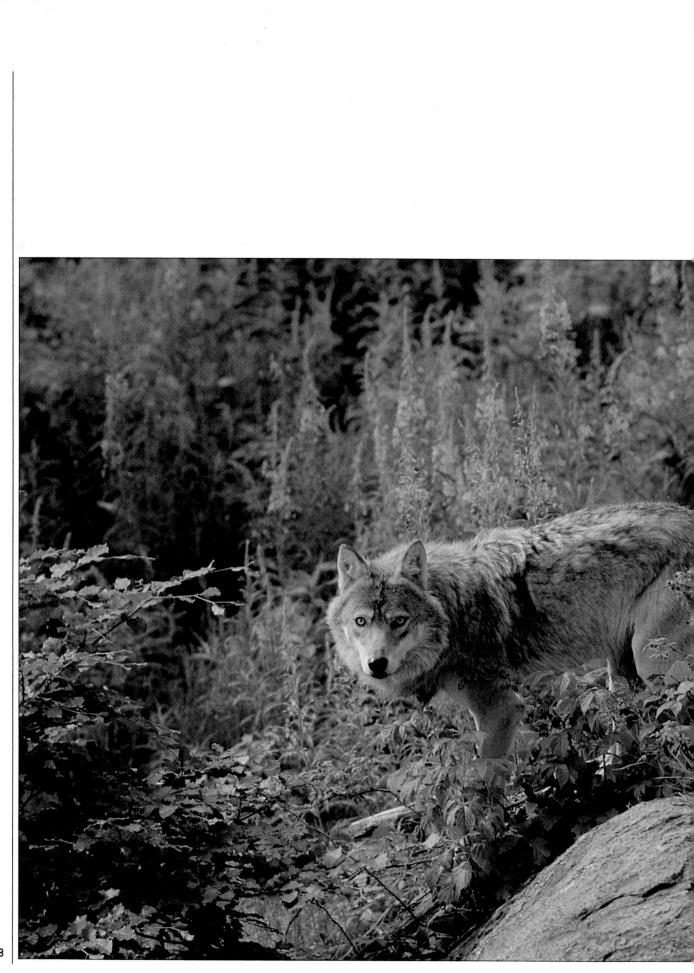

ANIMALS AND PLANTS

Animals and plants are the living components of the landscape. To photograph them successfully, you need a special alertness combined with techniques borrowed from the tracker and the naturalist. It takes knowledge of animal habitats and also stalking skill to approach a wild creature such as the wolf in the picture at left. And it takes quick reflexes to get an accurately focused picture before the animal vanishes. Alternatively, you may need to cultivate the patience to wait in a well-chosen but possibly uncomfortable location until the animal appears – or perhaps does not appear at all.

In compensation for these difficulties, the rewards are tremendous. The thrill of getting close enough to an elusive subject to frame it in your viewfinder is something that few other areas of photography can offer. If you are well prepared, you can usually find the subject you want, and wildlife preserves will offer plenty of practice without your needing to travel to exotic locations. The section that follows deals with techniques and equipment that will help you capture pictures of subjects as different as a herd of deer, a backyard squirrel or the challenging simplicity of a single flower.

A timber wolf, caught unawares, glances toward the camera. While hiking through the backwoods, the photographer saw the subject and took the picture quickly with a 135 mm lens before the wolf turned and fled.

Places to go

The first rule of wildlife and plant photography – so obvious that you may easily overlook it – is to make sure you go to the right place at the right time. You are unlikely to find great animal pictures by merely wandering through the woods with a camera. For example, you can trek for days through the backwoods of Maine, Canada or the northern Rockies without seeing a single moose, while a visit to Yellowstone National Park will almost certainly offer several good sightings, such as the one at right.

National parks and wildlife sanctuaries are not only full of animals and interesting plants but also often have facilities that make subjects relatively easy to find. Special viewing places and nature trails give the public access to areas that might otherwise be inaccessible, as in the Florida Everglades, where some sites have raised boardwalks over swampland. Even without these facilities, wardens, rangers and official guides can provide specialist information and help lead you toward your quarry.

Many publications offer advice on where to find wildlife. For example, by using a regional field guide you can discover the whereabouts of nesting bird colonies, such as the one below, and whether it is possible to visit them, perhaps as part of an organized trip with a natural history society. For a particularly fine chance of taking spectacular pictures, such as the one at the bottom of the opposite page, you could take a safari vacation to the great game parks of Africa or India, where overland transport to the best sites is specially organized for photographers and wildlife enthusiasts.

A bull moose (right) *wades across the Madison River in Wyoming. The photographer used a 400mm lens from a distance of about 50 yards and based the exposure on the glittering water to leave the animal silhouetted.*

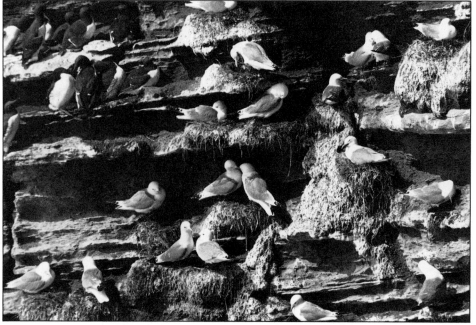

Seabirds (left) *nest on a rocky cliff face. By using a 300mm telephoto lens, the photographer was able to leave the birds undisturbed and find a camera position at the top of a cliff across a small bay from the birds' nesting area.*

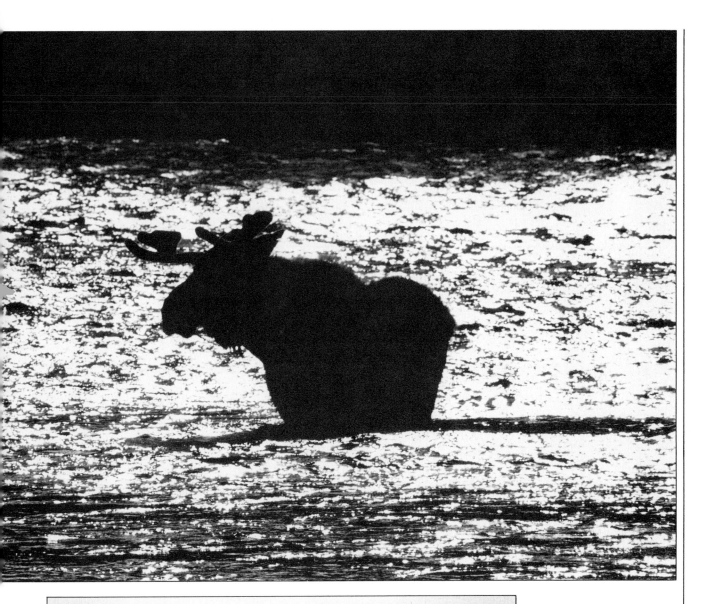

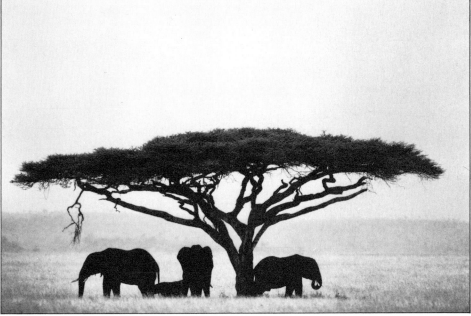

African elephants (left) shelter beneath a spreading tree, the only shade in this part of the game reserve. On an organized photographic trip, the photographer steadied his 400mm lens against the side of the expedition's parked jeep.

Finding animals

None of the pictures on these two pages would have been captured without some knowledge of the habits of the animals in question. Learning a little of the annual, seasonal and daily routines of wild creatures helps you find and photograph them; the most successful wildlife photographers are to some extent naturalists as well.

Most animals share a few behavioral characteristics that can help you to locate them. For example, mammals and birds tend to be particularly active shortly after sunrise and just before sunset, when many move to and from water, nests or dens to look for food. The deer at right have come to drink in a stream in the evening. And a forest clearing that seems desolate by day may come alive with grazing deer and feeding birds at dusk. As another useful pointer, remember that sources of food and water will most likely attract creatures in times of hardship. In the dryness of high summer, waterholes and streambeds provide perfect opportunities for photography of a whole variety of animals.

However, in each location and with each individual species, the details of behavior will vary and you need to use any local knowledge you can find. Pamphlets on sale at National Parks and other wildlife sanctuaries help, but a park ranger will give you even better information if you ask. Having a trained guide accompany you may seem to reduce the sense of adventure but will greatly increase your chances of getting good pictures.

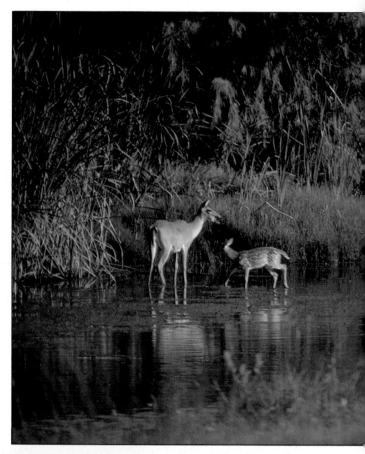

A doe and her fawn come to a stream to drink in the Aransas Wildlife Reserve, Texas. A 300mm lens framed the subjects from the cover of trees, with warm evening light showing their color to best advantage.

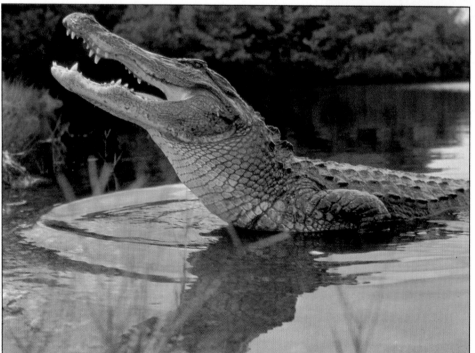

An alligator lies in the shallows of the Florida Everglades, mouth open for cooling in the humid heat. Guided to the basking creature, the photographer was able to approach close enough to use a 105mm lens.

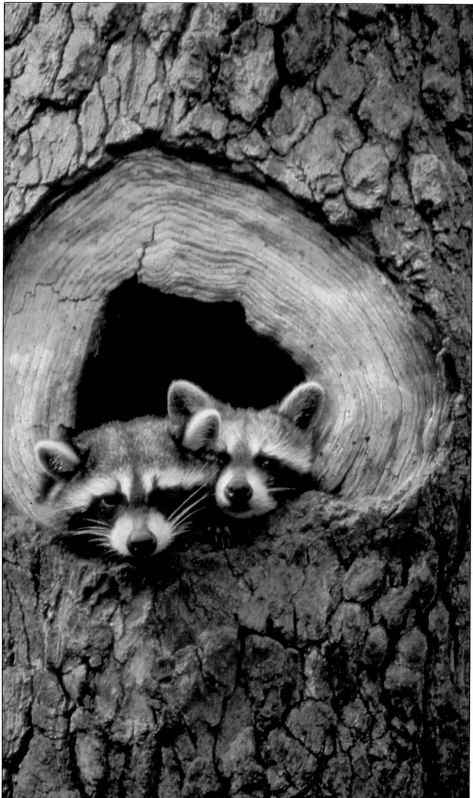

Two young raccoons peer out from their den in a pine tree. Knowing where to find them, the photographer waited with a 200mm lens until the two brightly marked faces appeared.

Dress and equipment

When wearing normal clothes and moving about in a normal way, a human being represents one of the most visible, noisy and strongly scented of all potential enemies to a wild animal. So if you want to photograph anything more than the animal's tail vanishing into the distance, be very careful about what you wear and what you carry.

If you are stalking animals on foot, you must do your best to blend into the surroundings. Even if you do not go to the lengths of wearing full camouflage, always try to be aware of how the animal will see you. Most animals, such as the jackrabbit at right, are sharp eyed, highly sensitive to movement and equipped with senses of smell and hearing that far surpass those of humans.

As a first precaution, wear drab clothing, preferably similar in tone and color to the surroundings, and remove anything that might catch the sunlight,

such as a wristwatch. If you have fair skin, wear some headgear to darken or shadow your face, as shown below. Empty your pockets of any coins or keys that might jangle as you walk. And avoid wearing artificial scent or deodorant; human body scent is alarming enough to animals without the addition of extra smells. Loose clothing that buttons at the wrists and neck, together with long trousers, will help to conceal your scent.

Carry as few pieces of equipment as possible so that you can walk more quietly. Unless you have established a fixed position in advance, you will never have time to set up a tripod, change lenses or attach filters. The figure illustrated below is well equipped with two cameras, one with a very long lens and the other with a moderate telephoto lens. Carry a few rolls of film and a spare camera battery in your pockets, avoiding a shoulder bag if possible.

Camouflage

The best clothes for stalking animals are military surplus items, which are also cheap and comfortable. But there is no need to overdo it; the basic rule is to avoid garments that are notably lighter or darker than your surroundings.

A hunting vest (left) has useful pouches for equipment, but you must wear a long-sleeved shirt. A hooded jacket (right) will hide your face in shadow.

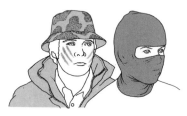

Streaks of dirt or camouflage makeup on your cheeks (left) will make you less conspicuous at a distance. A dark woolen helmet (right) serves the same purpose.

A broad-brimmed camouflaged hat will keep direct sun from lighting up your face.

Dirt or streaks of makeup on the backs of your hands will disguise them – important, as hand movements can alert shy animals to your presence. You can also wear dark gloves, if they do not make camera handling difficult.

This photographer carries two cameras on their straps around his neck. One has a 300mm lens, the other a 180mm lens.

Pockets should be large enough to carry extra film and spare batteries.

Shoes should be sturdy, but light, so you can move noiselessly over rough ground.

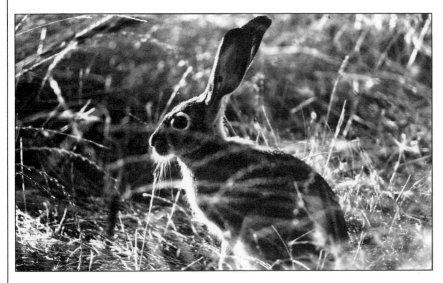

A blacktail jackrabbit sits alert in tall grass. The photographer came across the animal in the late afternoon and crept closer from the dark cover of trees, using a 300mm lens to close in.

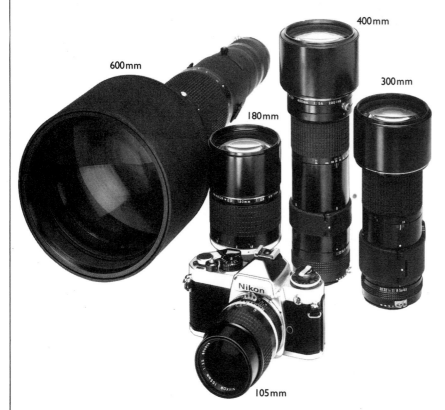

600mm

400mm

180mm

300mm

105mm

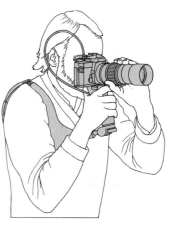

Shoulder stock (above)
This additional support for a telephoto lens helps keep the camera steady and allows you to concentrate on the animals appearing in the viewfinder.

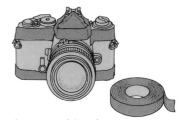

Taping the camera (above)
Black tape on shiny camera surfaces reduces the risk of metal glinting in the sun. Lightly cover the prism head and the front of the top- and base-plates.

Lenses for wildlife (above)
Telephoto lenses are essential, allowing you to fill the frame with animals that you cannot approach closely. Zoom lenses, though more compact, have the drawback of smaller maximum apertures for each focal length, reducing their vital light-gathering power. The longer lenses shown here, 400mm and 600mm, need the support of a tripod and thus are most suitable for use from blinds. With a steady hand, you may be able to handhold a 300mm lens at a speed of 1/250, making it suitable for stalking if you use fast film. The 105mm and 180mm lenses have large apertures and are ideal in woods, where you may encounter animals close up.

Telephoto lenses

When looking at a wildlife subject through a long telephoto lens, one of the most striking things about the image is the shallow depth of field, particularly when the lens is set at a wide aperture. Although the narrow zone of sharp focus may seem to present a problem, in practice you may find it often helps you. Lying in wait, you can conceal yourself and your equipment behind vegetation, and the lens will throw the intervening screen of foliage out of focus, as in the picture at bottom right. With a fixed-aperture mirror lens, used for the picture below, out-of-focus highlights acquire a brilliant sparkle — an effect created by the mirror elements within this type of lens, which fold up the light path and thus make the lens more compact.

Shallow depth of field is sometimes also useful to isolate small subjects. For example, in the picture at right, the out-of-focus background draws attention to the birds, despite their relatively small size.

To shift focus with a telephoto lens, you must turn the focusing ring farther than on a standard lens, and if you come upon an animal unexpectedly, an extra second spent focusing can mean a missed picture. You can reduce this risk if you keep the lens always set to a point in the middle distance, so that you need to make only small focusing adjustments.

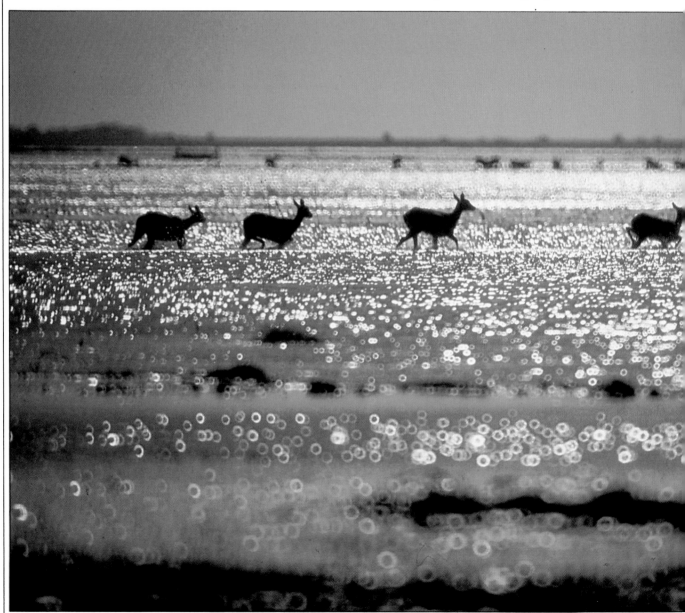

Led by a stag, kudus splash across a flooded African plain. A 500mm mirror lens picks them out against the light and creates a shimmering wash as highlights in the out-of-focus foreground reproduce as discs – a characteristic effect of this lens. Since the aperture was fixed at f/11 the photographer had to use a fast shutter speed to prevent overexposure.

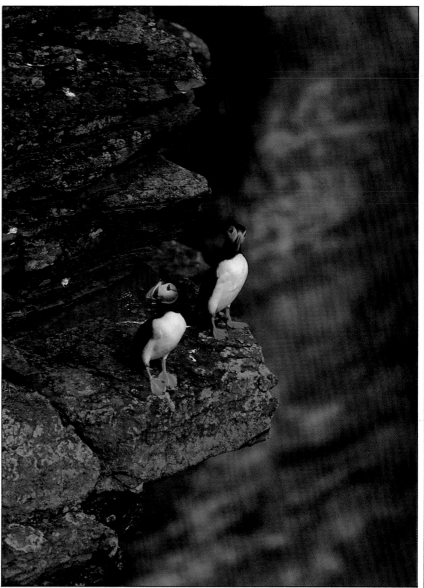

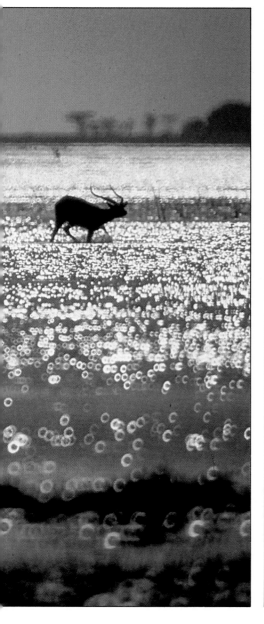

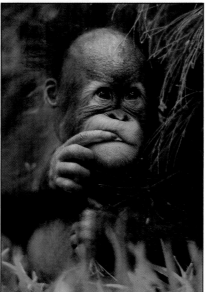

A pair of seabirds perch on a cliff face. The photographer set up his camera on a tripod at the cliff edge, focused carefully on the ledge at a wide aperture and waited until the puffins landed on one of their favourite perches.

A baby orangutan waits for its mother, and the photographer's 300mm lens crops tightly in on its anxious expression to make a striking animal portrait taken from a hidden position.

Getting closer

Around every wild animal is an invisible boundary – a territory, within which any intrusion or disturbance will trigger alarm.

As soon as you approach too close, the animal will simply leave or make for a safe hiding place. You may get a blurred view of it bolting – or you may never see your potential subject at all. Pictures in which animals seem as unaware of the camera as the red deer on the opposite page require very great care and skill in stalking, even when you are using powerful telephoto lens.

Learn to use the skills of the woodsman. Look for the quietest paths, avoiding dry, crackly undergrowth or mud that will squelch underfoot. Choose routes across the countryside that give natural cover

– for example, the shelter of rocks or trees. And keep below the tops of ridges to avoid showing up on the skyline. Take note of the direction of the wind, and if you have the choice, walk with the wind in your face or to one side so that your scent does not drift ahead, signaling your presence.

When you see a subject in the distance, stop for a moment and take stock. The illustration below shows a sample situation, with some suggestions about how you might approach animals you have sighted. If the animals look at you, stop and remain still until they look away. Above all, be patient, and do not expect to get too close. If you think the animals may move off before you reach your chosen position, try taking one or two pictures on the way.

Crossing open ground
This view of wooded country indicates the kind of first view you may have of animals you want to photograph. There is a considerable distance to cover, and several routes are possible.

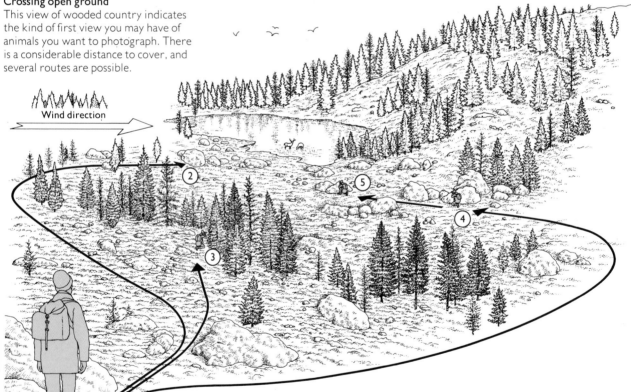

Wind direction

1– At the starting position, the photographer is close to the skyline. Take care to stay low at this stage.

2– The most promising goal is a rock close to the deer. But the wind direction rules out an approach from that side.

3– A cautious plan would be to move slowly down to the trees below the starting position and use them as a protective screen.

4– Another route, involving a long, slow walk, crosses the floor of the valley to the other side and then swings back behind rocks and trees toward where the deer are grazing.

5– Having taken some pictures from a safe position without frightening the deer away, you could move to a much nearer rock – and with luck get a really good close-up.

In a sunlit Bavarian glade, a pair of deer stand silently unaware of the camera in an image that sums up the peace of the woods. The photographer carefully approached them with a telephoto lens to a distance of about 20 yards.

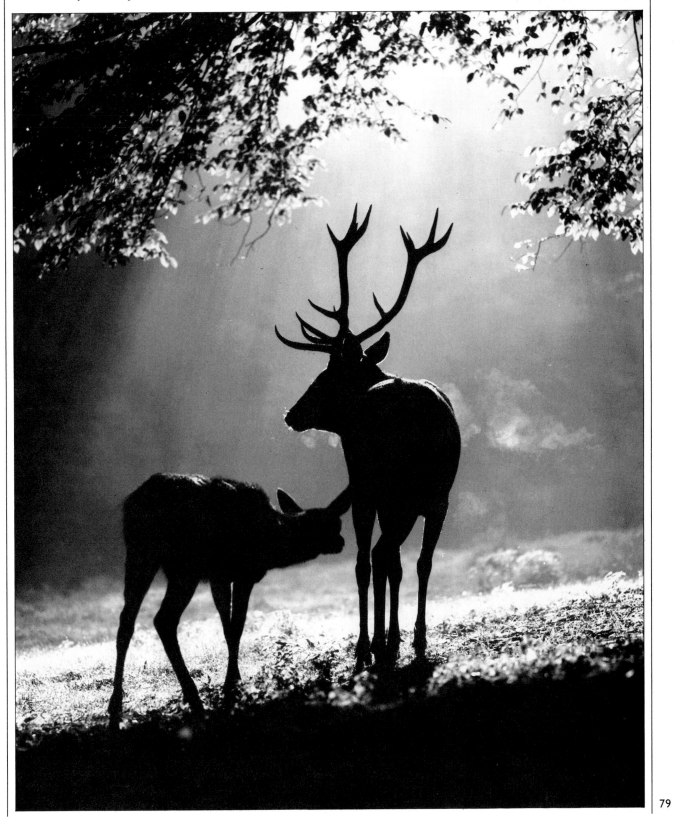

Using vehicles

Stalking on foot may be exciting but it is not always the best way to approach animals in the wild. A car or boat will often leave wildlife relatively undisturbed, because animals do not necessarily associate vehicles with the presence of people inside. This is especially true when vehicles are a regular sight, as they are in many national parks. In these conditions, the animals become accustomed to seeing and hearing cars and learn that they represent no threat.

The picture of the leopard below was taken from a vehicle specially modified to carry visitors through an African game park, but the same advantages apply in less exotic locations; a vehicle both protects you from potentially dangerous animals and allows you to approach them closely. For example, the bear at right was photographed near a roadside in Alaska.

Even if your subject is not dangerous – perhaps a bird of prey you have spotted perching on a branch while you are driving past – you probably have a better chance of getting a picture if you stay inside the vehicle. However, be careful how you stop the car. Coast gradually to a halt and leave the motor running for a while before you switch it off. Try to wind down the window when the animal is looking away and set up the camera as quietly as possible.

Boats can be even more useful vantage points. With the motor off, you can drift with the stream or stay anchored without disturbing aquatic animals, sometimes getting really close, as with the heron at the bottom of the opposite page.

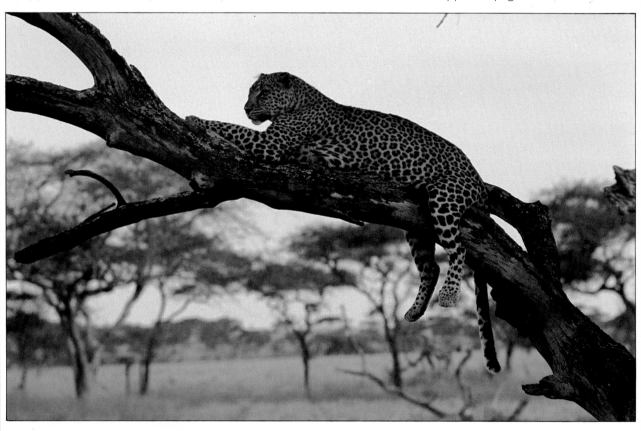

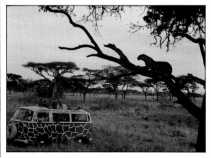

A leopard (above) rests on a dead bough – a classic picture by a famous wildlife photographer, Eric Hosking, who approached the animal in a safari van and used a 200 mm lens from 25 yards. A similar van (left) accompanied the one in which the photographer was traveling, but still did not disturb the impassive beast.

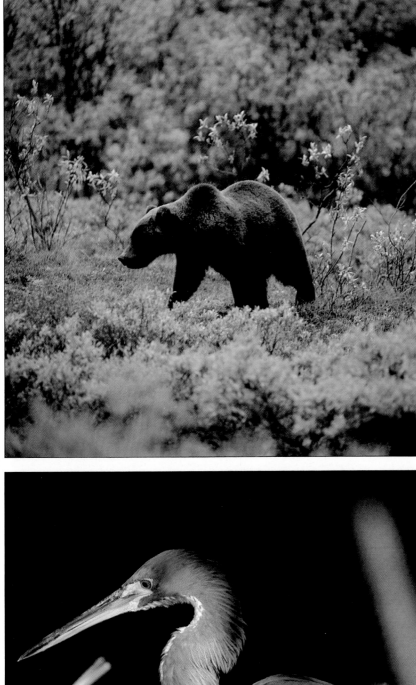

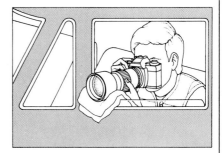

A grizzly bear walks through scrub close to the side of the road. A 400mm lens gave good detail of the subject from a distance of about 40 yards. To use a telephoto lens from a car window for such pictures, a folded jacket makes a good improvised support, as shown above.

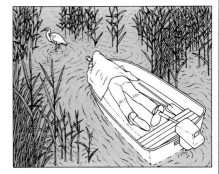

A heron fishes among reeds in the Florida Everglades. The photographer switched off his boat engine so that he could drift quietly into the reeds where he had seen the bird, as shown in the illustration above. Covered by a coat and remaining motionless, he was able to float to within 14 feet, sufficient with a 300mm lens for a close-up of the heron in dappled sunlight.

Using blinds

Hidden inside a camouflaged shelter – or blind – you can take pictures of wildlife from a closer viewpoint and with less risk of disturbing the subject than if you were in the open. For this reason, nature preserves often provide permanent blinds in the form of wooden structures built alongside viewing areas. But usually a blind is a small, tent-like structure either ready-made or improvised as shown in the information box below at right.

Although a blind hides you from view, wild creatures are almost as wary of unfamiliar structures as they are of people, and you may have to inch the blind forward over a period of days before you can take pictures. For the study below, the photo-grapher took this precaution but still had to spend many hours watching from the blind before the stork returned to a normal pattern of activity.

To avoid arousing suspicion, try to enter the blind when the animals are not around, or else enter with a friend, who then leaves shortly after. Animals cannot count and may assume that just one person has made a brief visit and then gone away again.

Once inside, keep as quiet as possible and do not touch the walls, as any movement of the blind may be detected. When the shelter is empty, leave a dummy lens such as a bottle in place, so that your own lens does not appear so alien when it protrudes from the blind.

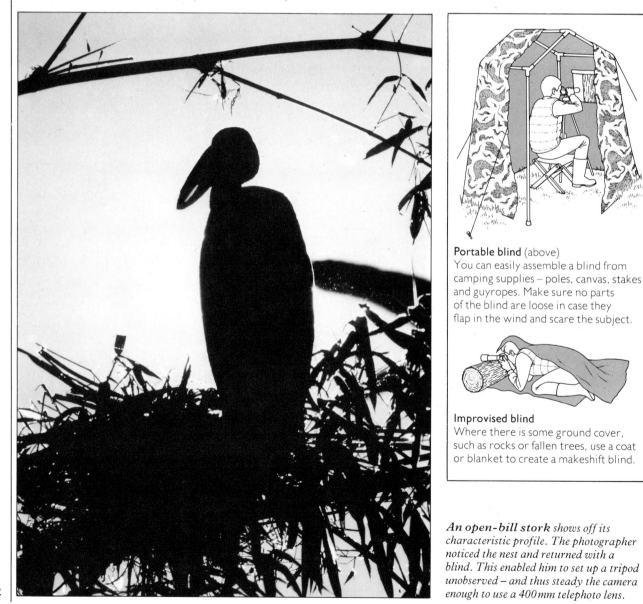

Portable blind (above)
You can easily assemble a blind from camping supplies – poles, canvas, stakes and guyropes. Make sure no parts of the blind are loose in case they flap in the wind and scare the subject.

Improvised blind
Where there is some ground cover, such as rocks or fallen trees, use a coat or blanket to create a makeshift blind.

An open-bill stork shows off its characteristic profile. The photographer noticed the nest and returned with a blind. This enabled him to set up a tripod unobserved – and thus steady the camera enough to use a 400mm telephoto lens.

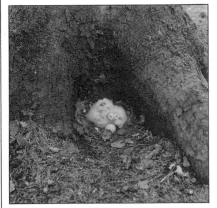

Tawny owl chicks (left) in a ground
nest are a rare sight – owls usually nest
in trees. From a blind 20 feet away, the
photographer was able to take pictures
of the young without disturbing them
or the adult birds.

A running fox (below) passes a blind,
and is oblivious to the photographer
inside. Sited close to the fox's den, the
blind gave a good view as the animal
made occasional forays in search of food.
The photographer waited lying full-length
and used a 135mm lens.

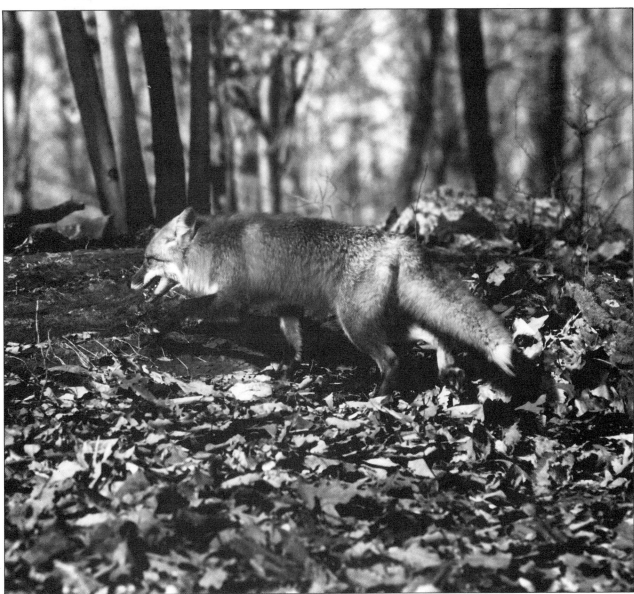

Remote control

If an animal is too timid to approach closely – or dangerous like the lion at right – the best way to take a picture may be to operate your camera by remote control. This is only practical if you have an automatic exposure camera that has a motordrive or winder. Otherwise, you can take just one picture before returning to the camera.

The simplest remote device is a twin-strand cable with a pushbutton at one end; pressing the button releases the shutter. An infrared remote release (see below) is rather more reliable and convenient than a cable, especially if the camera is set up some distance away or on the other side of a natural obstacle, such as a river.

To take pictures by remote control choose a likely location or else put down bait to attract the animals. Set up the camera on a tripod, and if you are photographing a naturally cautious animal, disguise the camera and tripod with vegetation. Then, retire to a distant vehicle or some other viewpoint in sight of the camera and wait. Before making the actual exposures, take two test pictures to make sure the equipment is working properly. You can also use binoculars to watch the rewind knob, which generally turns each time film advances.

A curious lioness pads toward a remote controlled camera, and an 18mm wide-angle lens makes the lion seem dangerously close. Had the photographer used a telephoto lens from his jeep window, the viewpoint and perspective would have made the image much less dramatic and menacing.

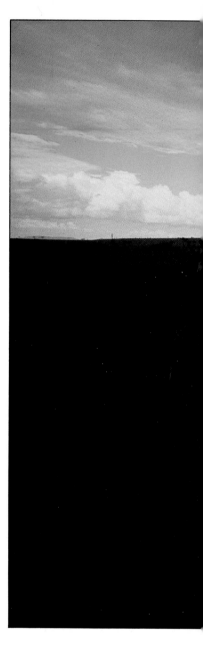

Infrared remote release
This type of remote control consists of two units: the handset (right), which the photographer holds, and the receiver, which slides into the camera's accessory shoe and operates the shutter via a short cable, as shown above. Pressing a button on the handset fires a brief pulse of infrared radiation, much as a flash unit fires a burst of light. The receiver detects this burst of infrared and closes the contacts that cause the shutter to be released. The maximum range is about 100 yards; beyond that you need a radio control system.

Electric cable release
A long cable with a switch (below) works satisfactorily over short distances. But the electrical resistance of the wire will cause problems if photographer and camera are very far apart.

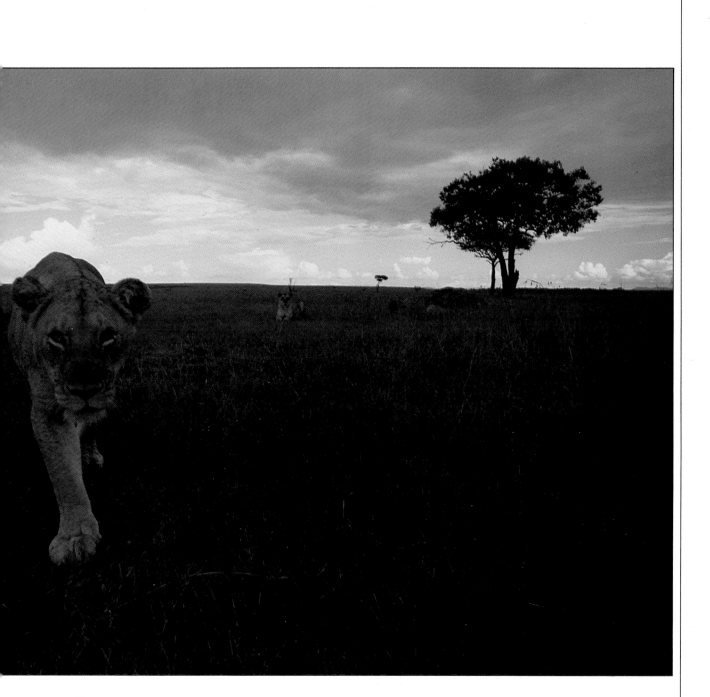

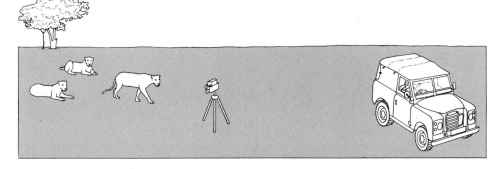

Lion's-eye view
The photographer, on safari in East Africa, wanted a wide-angle lens picture (above) that would show the lion from a low viewpoint. He used an infrared remote release but kept his vehicle near the camera to scare off the animal if it threatened to damage the equipment.

Wildlife with flash

Many animals – mammals in particular – become active only as night falls. Nature pictures taken with flash at night have a special vividness, perhaps because they show us a world of hidden activity.

Nocturnal animals can see in the dark much better than humans. Nevertheless, if you give your eyes 20 minutes or so to adapt to the darkness, you will find that they become more sensitive, particularly to movement at the periphery of your vision. To stalk animals at night, you must be aware of everything around you and not look fixedly ahead.

If the night is black, carry a flashlight with a cardboard snoot that narrows the beam. Far from causing alarm, a bright light often mesmerizes animals and may pick up the telltale twin reflections of their eyes, giving you a useful guide to focusing. However, the best chance of getting pictures such as the one of the badger on the opposite page is to wait patiently in a suitable camera position and use a remote release if necessary.

Unless the subject is very close to the camera, use the most powerful flash you can. Outdoors, with no reflective surfaces, the light loses intensity quickly, so you should first check what range your unit provides by making some test exposures at different distances. Even with a powerful flash, you should use a fast film of ISO 400 or ISO 1000 for subjects more than a few feet away.

Flash is useful during the day also if you want to freeze fast-moving subjects; the picture of a hovering hummingbird below shows just how fast flash can be. However, the unit must be close to the subject so that the burst of light is very short and bright enough to overpower the daylight.

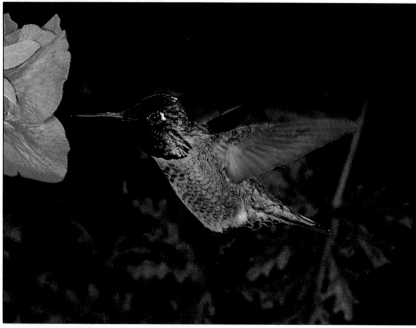

A tiny hummingbird sips nectar from a flower, its wing beats frozen by twin automatic flash units. Despite the very brief flash duration (1/10,000) the bird's wing tips are still slightly blurred. The photographer placed the camera on a tripod, as shown below, and used a 100mm macro lens at f/11.

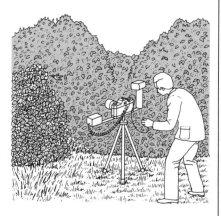

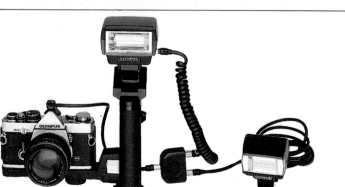

Flash equipment
For tiny subjects, such as the bird in the picture above, flash units like the one at left provide ample power. In addition, their exposure-regulating circuits provide a useful way to control flash duration, as they curtail the flash quickly when the subject is close to the flash unit. To soften harsh shadows or to create more even lighting, it is possible to link two or more flash units with a cable, as here, or to trigger them with a remote control device.

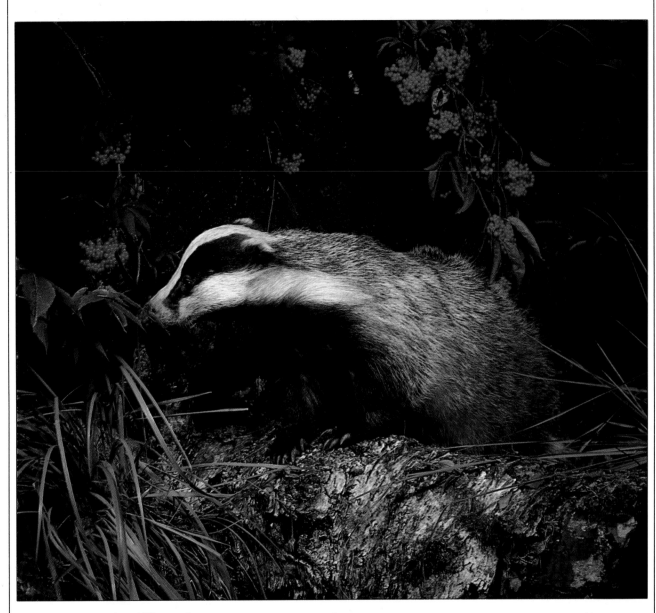

A badger emerges from hiding, and a flash unit illuminates it brilliantly. The photographer located the den by day, and set up the camera and flash while there was still enough light to focus. He used a tripod to support the motor-driven camera, and attached the flash unit to a stand as diagrammed at right. When the animal appeared, the photographer triggered the camera and flash with a remote release.

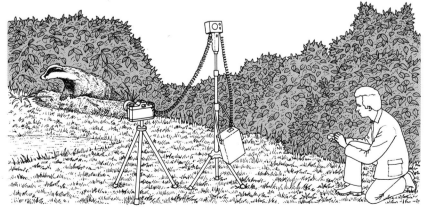

Birds in flight

When on the ground, birds can seem ungainly and awkward; their true grace and beauty emerge only in flight. Try to take pictures when the birds are close enough to fill a good area of the viewfinder frame. If you are using a telephoto lens, large species such as herons, storks and pelicans present good subjects, even at a height. But often the best moments to capture birds are when they are taking off or landing, particularly if you can include a reflection in the frame, as in the picture at top right.

Focusing on a speeding subject presents problems even for the most experienced photographer, but there are ways around this difficulty. Many species of birds hover steadily on thermals and updrafts. For example, seagulls tend to follow boats at a fixed distance, so that framing and focusing are easy as the birds spread their wings to catch the rising air.

For a bird flying toward the camera, preset the focus and press the shutter release when the bird begins to look almost sharp. The fraction of a second that always elapses before the shutter opens allows time for the bird to fly into focus.

When the direction of flight is past the camera, you should pan to follow the birds, as the photographer did for the picture at right center. Birds usually follow a fixed route when leaving or returning to a nest, so you may get several chances to take the same picture.

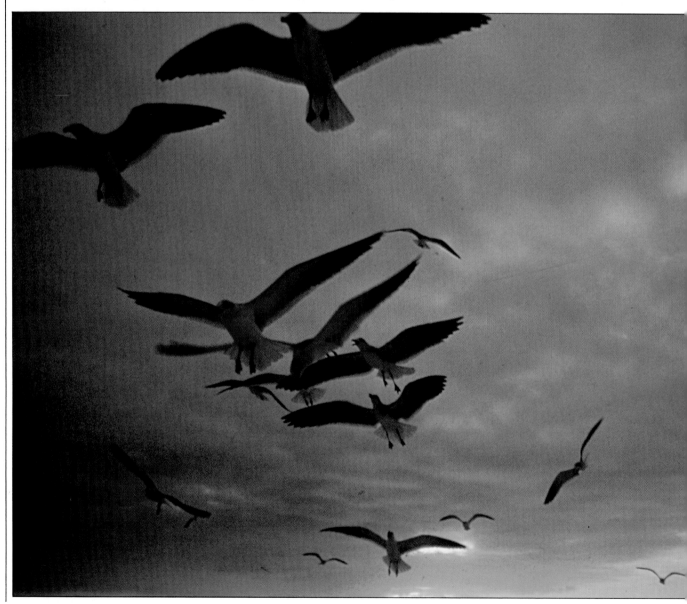

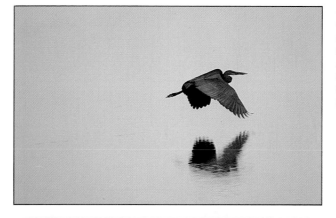

A heron takes flight and a 300mm lens isolates the elegant outline against the surface of the water. Laboring to gain height, the bird was slow enough to allow the photographer to take several pictures.

Soaring seagulls *(below)* present an easy target as they hover above the deck rail of the boat on which the photographer was standing. They were so close that even with a standard lens the birds appear sufficiently big to dominate the picture.

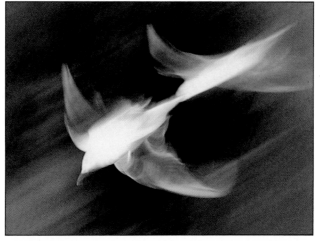

Speeding birds flash past the camera, their outlines blurred by a shutter speed of 1/15. The result is an image that sums up the magic of flight.

A tern *(below)* wheels around a high cliff top. The photographer preset the focusing ring on the 300mm lens and took a series of pictures as birds from a flock flew into the plane of sharp focus.

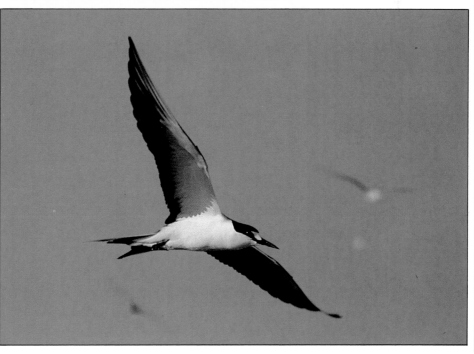

Animals in town and garden

Cities, towns and suburbs support a surprising variety of birds and mammals, and you can photograph much of this wildlife without even leaving the house. For example a camera set up in a living room captured the charming picture of the sparrow on the opposite page.

Birds are usually the easiest subjects to photograph at home. Attracting them is simply a matter of providing a nesting box, a water drip or a feeder. To make a water drip, just hang up an old bucket full or water, and prick a tiny hole in the bottom. The dripping water will catch the light and attract a variety of birds.

If you put out food or water regularly for a week or so, you should have enough visitors to make it worth setting up the camera. Nesting boxes require more patience, and may not attract a tenant until the following season.

Mammals are more difficult to photograph because many of them are nocturnal. However, some species, such as the raccoon and squirrel shown here, are up and about by day, and because they are larger than the typical town bird, you do not need to be so close or have such a long lens to photograph them. Mammals will come for bait just as birds do, but bait is not always necessary; most animals are creatures of habit, and often you can locate them by simple, quiet patience and regular observation.

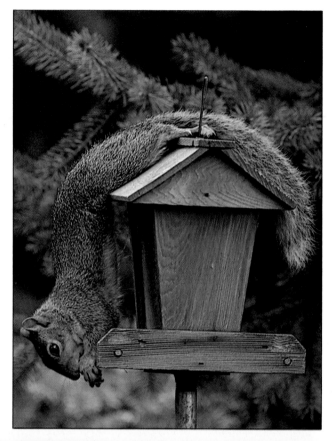

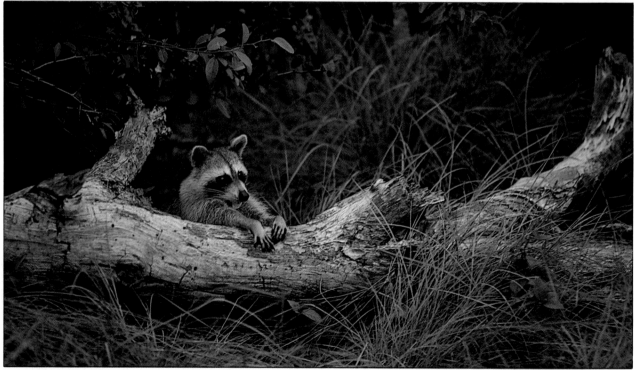

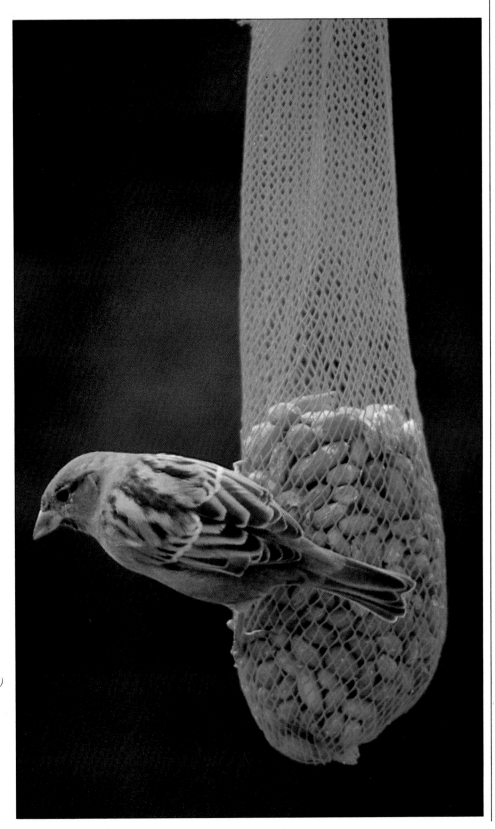

An agile squirrel (left)
raids a feed table, giving
the photographer a welcome
bonus – he had been expecting
birds. A 200mm lens filled
the frame with the feeder,
which had been set up nine
yards away from a window.

A young raccoon (left)
peeps out over a log before
taking the bait – a raw egg –
hidden nearby. By leaving an
egg in the garden closer each
day to a window where he
had set up the camera, the
photographer gradually over-
came the animal's shyness.

A common sparrow (right)
swings on a bag of nuts just
four feet from the camera.
Because the bait was so close,
a 135mm lens provided
enough magnification to get
an excellent picture.
But at that range,
the photographer had to
keep very still to avoid
scaring the bird.

Animals at the zoo

The time of day is almost as important in zoo photography as in the wild. To get effective pictures like that of the romping polar bear at the bottom of this page, you need to be on hand at feeding times or else arrive when the zoo opens and the animals tend to be more active.

There are some simple ways to make the animals' surroundings as well as their behavior look as natural as possible. Modern zoos that use moats and ditches rather than bars make it possible to screen out all surroundings except those that suggest the animals' natural habitat. One effective technique is to close in on the subjects as tightly as possible with a telephoto lens. You could even consider showing just a detail – an approach that works well for subjects that have strong color markings, such as the toucan below.

By walking around the subject, you may be able to find a camera angle that allows you to use lighting to hide evidence of an artificial environment. For example, in the polar bear picture, backlighting in bright sunlight has thrown into deep shadow the masonry walls at the back of the pool. And by aiming up high into the light, the photographer of the monkeys at the bottom of the opposite page suggested a jungle setting.

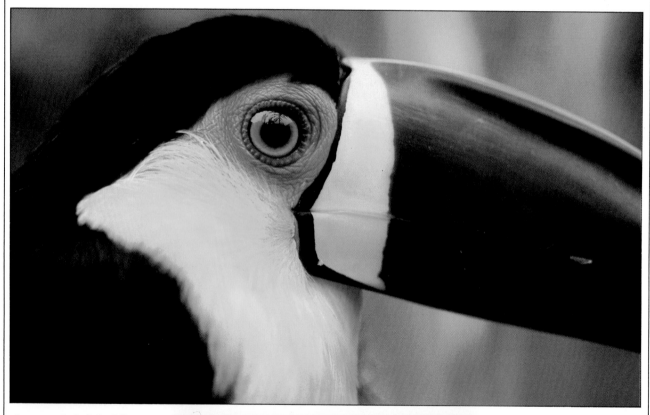

A toucan's bright bib of yellow feathers forms a marked contrast to the deep black of the majority of its plumage. The photographer set his zoom lens to its maximum focal length of 200 mm to frame the bird's head, bill and breast. At this focal length, the bars of the bird's enclosure blurred out.

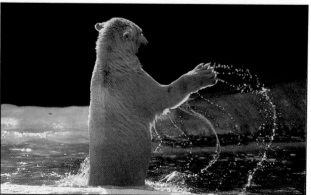

A polar bear splashing in its pool is caught by a fast shutter speed of 1/1000. The photographer took up his position across a moat just before feeding time, when the animal's impatience ensured a lively action picture.

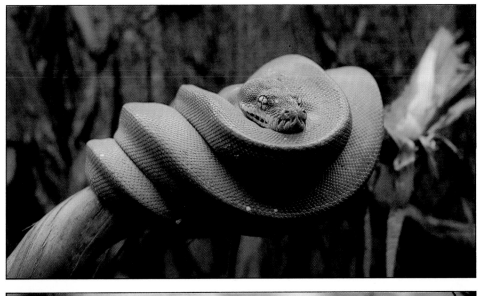

A green snake coiled on a branch makes an effective image. The photographer noticed the snake in a reptile house and chose an angle that would suggest a natural-looking background. A wide aperture helped to throw out of focus a concrete wall behind the branches.

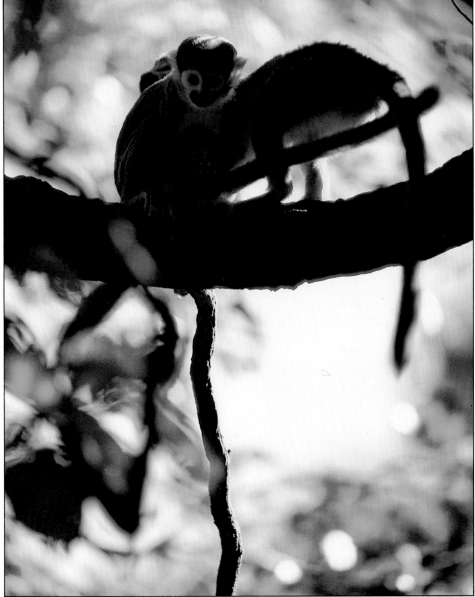

A pair of zoo monkeys chatter on a high branch in the Monkey Jungle near Miami. To avoid recording people and paths in the background, the photographer aimed up at the sky. He allowed an extra stop-and-a-half exposure so that the monkeys would not appear as silhouettes.

Insects

Insects are among the most accessible of all wildlife subjects. Because of their small size, they require close-up photography techniques and camera accessories. But these need not be expensive to acquire or difficult to use.

To take pictures as vivid as those shown here, you need to be able to focus within a few inches of the subject. Yet normal lenses (50mm or 55mm) are designed to focus no closer than about 18 inches, a distance at which a medium-sized butterfly will occupy only about one-fifth of the film frame. One simple way to achieve closer focus is to use extension tubes that move your lens farther away from the camera body. Usually, these tubes come in sets of three – for example, measuring 7mm, 14mm and 25mm. With the longest of these you can focus close enough for the butterfly to fill most of the frame, as in the picture at the top of the opposite page. Or you could increase the magnification by adding tubes together; the greater the length of the extension, the closer you can work to the subject.

Experiment to find the combination of tubes that achieves the image size you want with your chosen lens. An 80mm or 100mm lens may be best, allowing you to take pictures from slightly farther away and thus reducing the risk of disturbing the insect or throwing a shadow onto it.

If you have a strong interest in close-up photography, you should consider the special advantages of the so-called macro lenses. These are designed to work at close distances and can focus close enough

to produce an image as large as the one of the dragonfly below without any accessories. With extension tubes added, a macro lens can achieve magnifications well beyond lifescale. But at extreme magnifications, focusing becomes so critical that you need a tripod to keep the camera position fixed. Tripod-mounted equipment is cumbersome to use for live insects in the field, and the pictures here were all taken with a handheld camera.

In any close-up photography, the depth of field is always very shallow. To help overcome this difficulty, use the smallest aperture you can: even f/22 may not keep the full depth of a close subject in focus. For daylight pictures, such as the one of the dragonfly, the smallness of the aperture means that you will need strong sun to avoid slowing the shutter to the point at which you cannot hold the camera steady. Having chosen the smallest feasible aperture and moved the lens out as far as you need, focus by moving the camera rather than the focusing ring, gently rocking your body until the key part of the subject looks absolutely sharp.

Sometimes you will need to use flash to provide enough light. A small unit will do, but to avoid creating a confusion of shadows, move the flash forward to the side of the lens, preferably on a bracket; or better still, use a ring-flash unit. Both of these systems are shown on the opposite page. Make some tests to work out a suitable combination of aperture and flash output at a chosen focusing distance, then use the same setup for all your pictures.

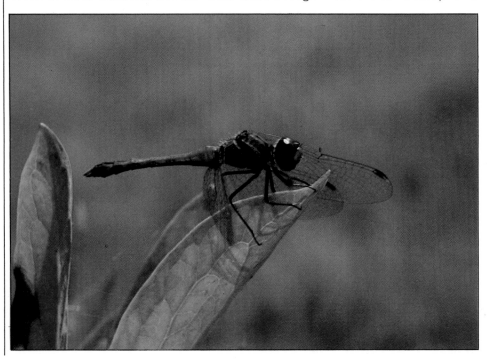

A dragonfly dries its wings. *A 100mm macro lens focused close enough for the two-inch-long subject to fill the frame. A small aperture of f/16 provided sufficient depth of field but needed a relatively slow shutter speed of 1/60 with medium-speed ISO 64 film.*

Ring flash

Many insect photographers use a circular ring flash, powered by a battery pack hung from the shoulder. Ring flash lights the subject from all around the lens and gives soft, near-shadowless results – sometimes slightly flat in appearance but with a compensating consistency, as in the picture at right.

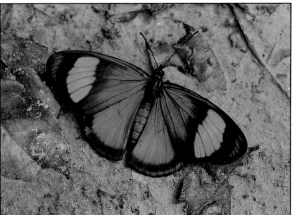

A Peruvian butterfly (above) takes warmth from the sand. The setup shown at right used a 100mm macro lens, without extra extensions, fitted with a ring flash.

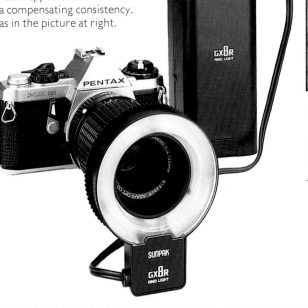

A citrus swallowtail butterfly (left) basks on a flower. The photographer used the setup diagrammed below, with a flash unit positioned to one side of the camera on a special flash bracket and a 50mm normal lens set at f/22, extended forward on tubes measuring 21mm.

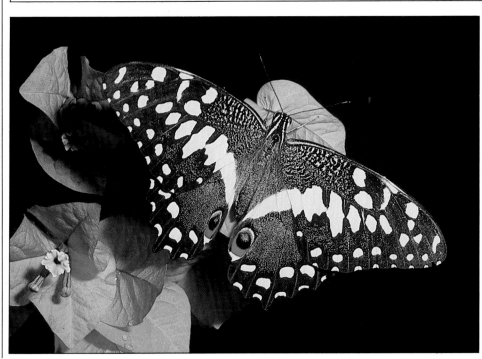

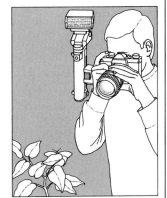

Flowers/1

Wildflowers can splash patches of bright, often startling, color across otherwise bare landscapes or form brilliant contrasts with the subdued browns and greens of foliage and trees. To make the most of such contrasts, try to relate the flowers to their surroundings. One way to do this is to select a viewpoint low to the ground and quite close to the plant, as the photographer did when taking the striking picture below.

For maximum depth of field, stop the lens down to a small aperture and use the camera's depth-of-field preview control to check that both flower and background are in sharp focus. If the flowers are sheltered, you may be able to balance a very small aperture by using a slow shutter speed, with the camera on a tripod or other support.

An alternative to this kind of richly detailed image is to throw foreground flowers out of focus so that only their intense colors catch the eye. Use a telephoto lens set at a wide aperture and focus on the background. In the picture at right, a mirror lens has spread the flower heads into blobs of color, almost as if dropped from a full paint brush, creating a picture that has far more impact and immediacy than one designed to record the flowers accurately, as a recognizable species.

Red and yellow flowers (right) contrast with the dull olives of woodland. A 500mm mirror lens produced a shimmering effect in the foreground flowers and in the equally out-of-focus background highlights. Such lenses save weight when you go walking, being much lighter than telephoto lenses of the equivalent focal length.

Claret-cup cacti (left) thrive on a barren crag above a valley in Big Bend National Park, Texas. To keep both parts of the picture in focus, the photographer used an aperture of f/16. The bright sunshine enabled him to set a shutter speed fast enough to stop the wind-blown blossoms from blurring.

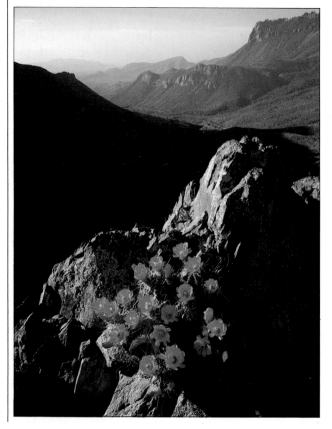

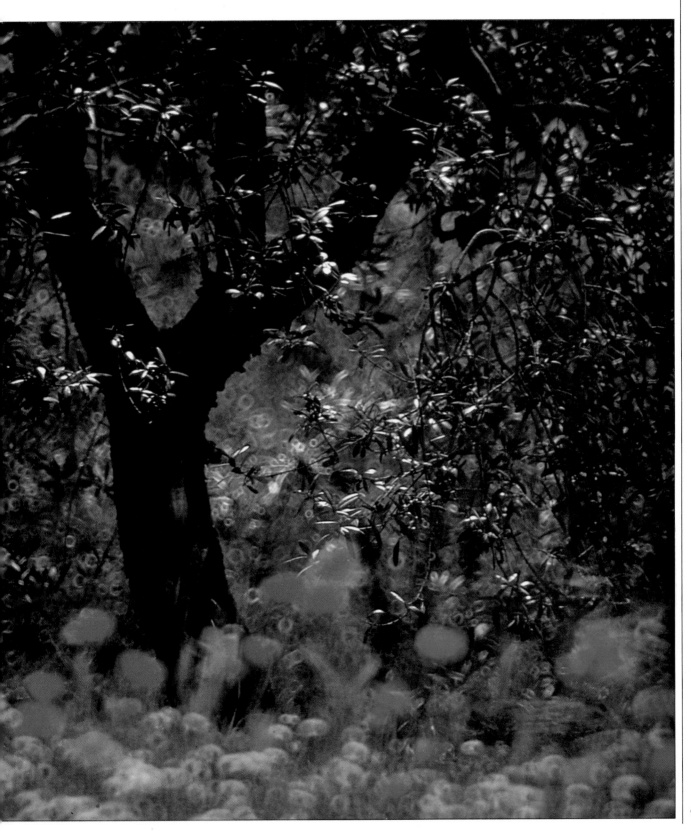

Flowers/2

A single flower isolated from its surroundings can make a strikingly beautiful picture. But to fill the frame with it, you must use careful close-up techniques, if necessary using the specialized equipment illustrated opposite. Begin by finding a good specimen that is not scarred or torn, then concentrate on simplifying the picture. Foreground or background foliage can easily become distracting unless you tidy up the area around the plant. Tie back superfluous flower heads or plants, especially those that are darker or lighter than the rest of the vegetation, as these will show up on film even if you try to blur out the background.

In flower portraiture, lighting is crucial. A good time to take pictures is early morning, when flowers are still fresh with dew. In the picture below, taken just after sunrise, the photographer used backlighting to isolate the flower. Later in the day, to avoid conflicting shadows, photograph flowers in the shade or when clouds diffuse the light.

Because depth of field is so shallow in close-ups, a small aperture is essential – and this may in turn force you to set a slow shutter speed. Secure the camera to a tripod, and in windy conditions wait for a moment of stillness before pressing the shutter release. When a breeze keeps a flower in constant motion, use a windbreak, which can also serve as a plain background. You can also place a length of stiff wire alongside the stem and use a spring clip to support the flower, as diagrammed at right below. Check through the camera's viewfinder to ensure that the clip does not appear in the picture.

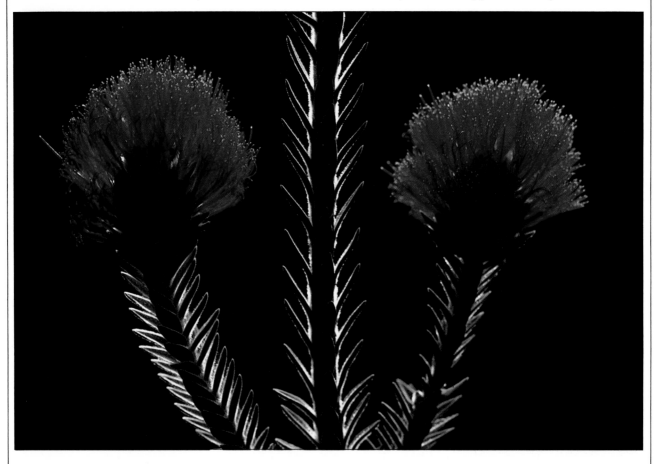

Brilliant red flowers *seem to glow when lit from behind. By framing the plant against a shadowed area, the photographer made an image that shows the spiked stem and flower heads with immaculate simplicity. The low sun also creates an effect of rimlighting that clearly reveals the plant's structure.*

Close-up equipment for flowers

Flowers are static subjects and allow a more considered close-up approach than do insects. For precisely adjusted framing and a steady camera, use a tripod. A 50mm or 55mm macro lens will let you close in on single blooms. Extension tubes used with a normal lens offer a cheaper alternative. To achieve the framing you want, try out different combinations of tubes. A bellows unit gives greater flexibility, enabling you to adjust the framing and magnification exactly as desired.

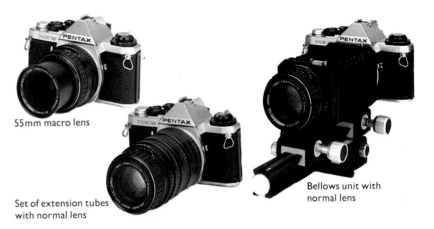

55mm macro lens

Set of extension tubes with normal lens

Bellows unit with normal lens

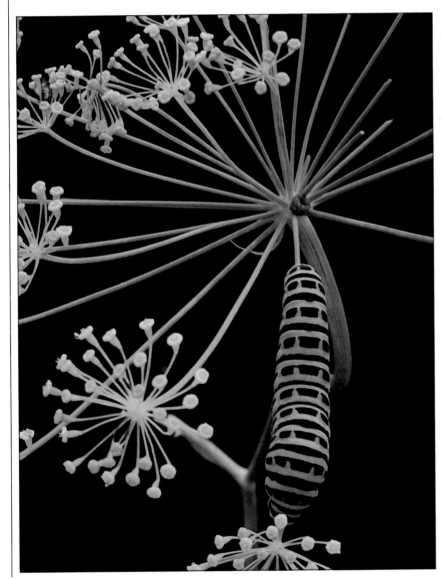

A caterpillar makes a perfect match with the flower head it feeds on. For this carefully prepared picture, the photographer used black cardboard as a contrasting background and supported the plant stem with a wire as shown in the diagram below. A bellows unit mounted on a tripod allowed perfect framing of the six-inch-high detail with a 50mm lens.

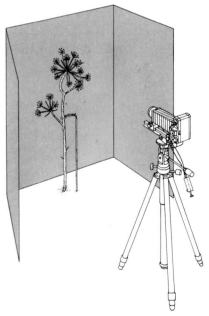

Hidden beauty in close-up

Close-up pictures of animal or plant subjects can reveal order where the eye sees only chaos. This is because a photograph encloses a detail within its frame, excluding all else and thus encouraging you to see the abstract qualities of the image. Even with the limited close-focusing capabilities of normal lenses and equipment, you can dramatize the patterns and colors of nature just by moving in on the subject, as in the picture below of the peacock showing off its feathers.

With the close-up techniques already suggested for photographing insects and flowers, you can dis-cover the forms and structures of nature on a diminutive scale – often revealing patterns that are hardly visible to the eye. The sunflower below, photo-graphed with a macro lens, displays a marvelous harmony of yellows in a complex and delicately interwoven pattern. The photographer concen-trated on these qualities by taking the picture from only a few inches away to include the very center of the flower and no more than a hint of the surround-ing petals. On a similarly small scale, the underside of a leaf, below right, reveals an intricate pattern that gains in impact by filling the whole frame.

A peacock (left) shakes its glorious feathers in sexual display. A 105mm lens tightly framed the bird's head, neck and tail feathers from a few feet away.

A network of veins (right) decorates the underside of a red and green leaf. For this close-up, the photographer used a 50mm lens mounted on a bellows extension, with a ring-flash unit and an aperture of f/11.

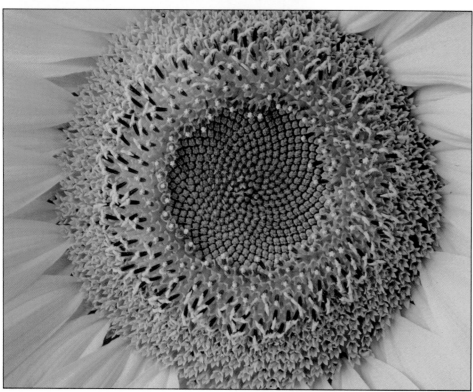

A sunflower (left) glows with color, its many elements forming a complex pattern of textures and repeated shapes. A 55mm macro lens gave the enlargement, with a daylight exposure of f/11 at 1/60 on ISO 64 film.

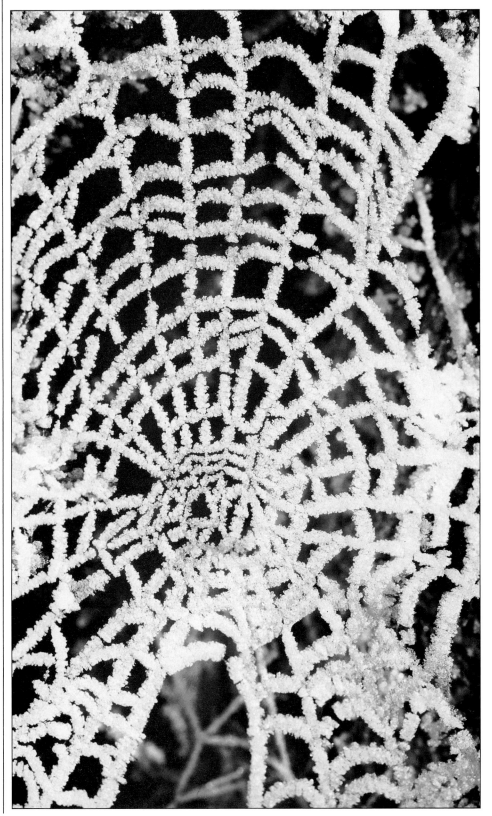

A spider's web (*left*)
bristles with grains of hoar
frost. Black-and-white film
emphasized the abstract, two-
dimensional pattern of light
on dark, closely framed by
a 50mm normal lens mounted
on extension tubes.

Glossary

Aperture
The opening in a lens that admits light. Except in very simple cameras, the size of the aperture can be varied to regulate the amount of light passing through the lens to the film.

Bracketing
A way to ensure accurate exposure by taking several pictures of the same subject at exposure settings slightly above and below (that is, bracketing) the presumed correct setting.

Cable release
A thin cable encased in a flexible plastic or metal tube, used to release the shutter when the camera is not being handheld. Use of the cable release helps to avoid vibration when the camera is mounted on a tripod for a long exposure.

Depth of field
The zone of acceptable sharp focus in a picture, extending in front of and behind the plane of the subject that is most precisely focused by the lens.

Diaphragm
The part of the camera that governs the size of the aperture. The most common type is the iris diaphragm – a system of overlapping metal blades that form a roughly circular opening, variable in size and similar to the iris of the eye.

Exposure
The total amount of light allowed to pass through a lens to the film, as controlled by both aperture size and shutter speed. The exposure selected must be tailored to the film's sensitivity to light, indicated by the film speed rating. Overexposure means that too much light has resulted in a pale image. Underexposure means that too little light has resulted in a dark image. Both extremes reduce detail.

Extension attachment
A camera accessory used in close-up photography to increase the distance between the lens and the film, thus allowing you to focus on very near objects. Extension tubes are metal tubes that can be added in different combinations between the lens and the camera to give various increases in lens-to-film distance. Extension bellows are continuously variable between the longest and shortest extensions. Bellows are more cumbersome than tubes and must be used with a tripod.

Film speed
A film's sensitivity to light, rated numerically so that it can be matched to the camera's exposure controls. The two most commonly used scales, ASA (American Standards Association) and DIN (Deutsche Industrie Norm), are now superseded by a new system known as ISO (International Standards Organization). A high rating denotes a fast film, one that is highly sensitive to light.

Filter
A thin sheet of glass, plastic or gelatin placed in front of the camera's lens to control or change the image.

Flash
A very brief but intense burst of artificial light, used in photography as a supplement or alternative to any existing light in a scene. Some small cameras have built-in flash, but most handheld cameras have a slot on top that takes a flash unit. Ring flash units are circular and fit around the lens. A ring flash casts no shadows and produces an image that is even and lacks contrast. It is used particularly for close-up work in scientific photography.

Lens
An optical device made of glass or other transparent material that forms images by bending and focusing rays of light. A lens made of a single piece of glass cannot produce very sharp or exact images, so camera lenses are made up of a number of glass elements that cancel out one another's weaknesses and work together to give a sharp, true image. The size, curvature and positioning of the elements determine the focal length and angle of view of a lens.

Lens hood
A simple lens accessory made of thin metal or rubber, used to shield the lens from stray light that does not come from the subject and can impair the image.

Long-focus lens
A lens that concentrates on only a small part of the subject, making distant objects appear close and magnified. Most long-focus lenses are of the type known as telephoto lenses. These have an optical construction that results in their being physically shorter than their focal length, and therefore easier to handle.

Macro lens
A lens specifically constructed for close-up photography, having its elements designed to give their best results when the subject is close to the camera. The special focusing mechanism of a macro lens permits sharp pictures from as close as three inches. Macro lenses are also used for normal photography at ordinary subject distances.

Mirror lens
A lens that uses curved mirrors to reflect light back and forth and so create a long focal length within a physically compact body. The main disadvantage of the mirror lens is that the aperture is fixed and usually quite small, preventing any control of depth of field. Light intensity can be regulated to a degree by use of a neutral density (ND) filter. Otherwise, exposures must be controlled by shutter speeds. The telltale product of the mirror lens is the ringed appearance of out-of-focus highlights, which can be used to striking effect. Such distortion is due to a blind spot, caused by placing the front mirror in the center of the first lens element.

Motordrive
A battery-operated device that attaches to a camera and automatically advances the film and resets the shutter after an exposure has been made.

Neutral density filter
A gray filter used to cut the amount of light entering the lens without affecting color balance.

Normal lens (standard lens)
A lens producing an image that is close to the way the eye sees the world in terms of scale, angle of view and perspective. For most SLRs, the normal lens has a focal length of 50mm.

Polarizing filter
A filter that changes the vibration pattern of the light passing through it. Chief uses are to remove unwanted reflections from a photographic image or to darken the blue of the sky.

Shutter
The camera mechanism that controls the duration of the exposure.

Standard lens see NORMAL LENS

Telephoto lens see LONG-FOCUS LENS

UV filter
A filter that absorbs ultraviolet radiation and helps to penetrate haze.

Wide-angle lens
A lens with a short focal length, thus including a wide view of the subject within the frame.

Zoom lens
A lens of variable focal length. For example, in an 80-200mm zoom lens, the focal length can be changed anywhere between the lower limit of 80mm and the upper limit of 200mm.

Index

Acknowledgments

Picture Credits
Abbreviations used are: t top; c center; b bottom; l left; r right.
Other abbreviations: BCL for Bruce Coleman Limited, MF for Michael Freeman, IB for Image Bank and SGA for Susan Griggs Agency. All Magnum pictures are from The John Hillelson Agency.

Cover Stephen Dalton/Photo Researchers

Title Mr and Mrs R.P. Lawrence/Frank Lane. **7** Thomas Ives/SGA. **8-9** K. Taconis/Magnum. **9** Bullaty/Lomeo/IB. **10** Jean Gaumy/Magnum. **11** John Hedgecoe. **12** Wisniewski/Zefa. **13** Morris Guariglia. **14-15** E. Sattler/ Explorer. **15** Bullaty/Lomeo/IB. **16-17** Bill Brooks/Daily Telegraph Colour Library. **18** Reflejo/SGA. **19** t Dennis Stock/Magnum, b Erich Hartmann/Magnum. **20** t Trevor Wood, b John Hedgecoe. **20-21** John Hedgecoe. **21** Paul Keel. **22** t John Sims, b Harald Sund/IB. **23** Andrew De Lory. **24** t, bl, br MF. **24-25** Erich Lessing/Magnum. **25** tl Dennis Stock/Magnum, tr Bruno Barbey. **26** John Cleare. **26-27** John Cleare. **27** John Garrett. **28** Michael Freeman. **28-29** L. Rhodes/Daily Telegraph Colour Library. **30** t, b MF. **31** t Dennis Stock/Magnum, b MF. **32** l MF, r Ernest Haas/Magnum. **33** t Ernst Haas/Magnum, b Ian Berry/Magnum. **34** t, b MF. **35** MF. **36** t Adam Woolfitt/SGA, b Richard Dudley-Smith. **37** l Dennis Stock/Magnum, r John Hedgecoe. **38** t Ed Buziak, B Graham Finlayson. **39** Fay Goodwin's Photofiles. **40-41** Jürg Blatter. **41** t Linda Burgess, b John Sims. **42** John Cleare. **43** John Cleare. **44** Robin Morrison. **44-45** M. Moisnard/Explorer. **45** t Francois Gohier/Ardea, b Robin Morrison. **46** Adåm Woolfitt/SGA. **47** t Ernst Haas/Magnum, bl John Cleare, br Larry Dale Gordon/IB. **48** t R. Ian Lloyd/SGA, b MR. **49** Uli Butz. **50** l, r John Cleare, **51** Peter Phillips/Trevor Wood Picture Library. **52-53** Martin Weaver/SGA. **54-55** Jean-Paul Ferrero/Ardea. **55** t, c, b MF. **56** Jean-Paul Nacivet/Explorer. **56-57** John Sims. **57** Pete Turner/IB. **58-59** Marc Riboud/Magnum. **59** t Ake Lindau/Ardea, b Andrew De Lory. **60** George Wright. **61** tl John Cleare, tr John Sims, b A. Nadeau/Explorer. **62** Krishan Arora. **63** t Ernst Haas/Magnum, b Alain Guillou. **64-65** John Sims. **65** t Lionel Isy-Schwart/IB, b Horst Munzig/SGA. **66** Trevor Wood Picture Library. **67** tl, bl MF, r Ch. Pinson/Explorer. **68-69** Jean-Paul Ferrero/Ardea. **70** David & Katie Urry/Ardea. **70/71** MF. **71** MF. **72** Jean-Philippe Varin/Jacana. **72-73** Farrell Grehan/SGA. **73** L. Lee Rue III/IB. **75** t Jeff Foot/BCL. **76-77** Ian Murphy. **77** t Jean-Paul Ferrero/Ardea, b Ira Block/IB. **79** Hans Reinhard/Zefa. **80** t, b Eric Hosking. **81** t Wisniewski/Zefa, b MF. **82** MF. **83** t Robert T. Smith/Ardea, b Leonard Lee Rue III/BCL. **84-85** Jerry Young. **86** t B & C Calhoun/BCL. **87** Hans Reinhard/BCL. **88-89** Dennis Stock/Magnum. **89** t Horst Munzig/SGA, c Max Hess, b Lionel Isy-Schwart/IB. **90** t Robert P. Carr/BCL, b MF. **91** Robin Laurance. **92** t Reflejo/SGA, b Jeffrey C. Stoll/Jacana. **93** t, b MF. **94** Jürg Blatter. **95** tr Gunger Ziesler/BCL, bl Les Dyson. **96** David Muench/IB. **96-97** Dennis Stock/Magnum. **98** Jean-Paul Ferrero/Ardea. **99** b Viard/Jacana. **100** tl Jean-Paul Ferrero/Ardea, tr Jürg Blatter, b Linda Burgess. **101** K.G. Preston-Mafham/Premaphotos.

Additional commissioned photography by John Miller.

Acknowledgments Carl Zeiss Jena Ltd, Dixons Professional Camera Ltd, Leeds Camera Centre, Nikon UK, Olympus Cameras.

Artist David Ashby

Retouching Roy Flooks

Kodak, Ektachrome, Kodachrome and Kodacolor are trademarks

Time-Life Books Inc. offers a wide range of fine recordings, including a *Big Bands* series. For subscription information, call 1-800-621-7026, or write TIME-LIFE MUSIC, Time & Life Building, Chicago, Illinois 60611.

Notice: all readers should note that any production process mentioned in this publication, particularly involving chemicals and chemical processes, should be carried out strictly in accordance to the manufacturer's instructions.